a photo journal

TO FISH IS LIFE

Peter Slater

Copyright © 2019 by Peter Slater
All rights reserved. This book or any portion thereof
may not be reproduced or used in any manner whatsoever
without the express written permission of
the publisher
except for the use of brief quotations in a book review.
Printed in the United States of America

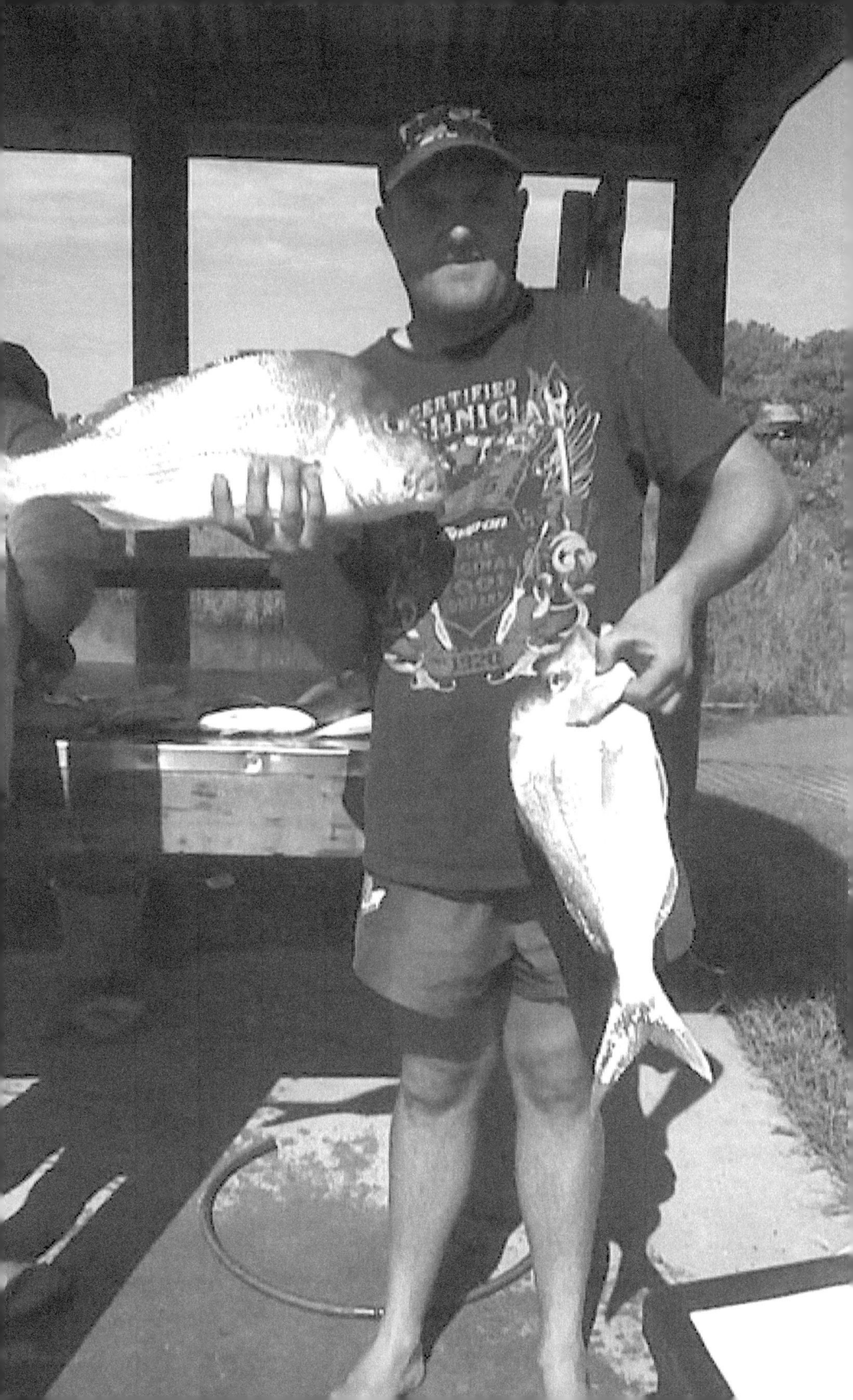

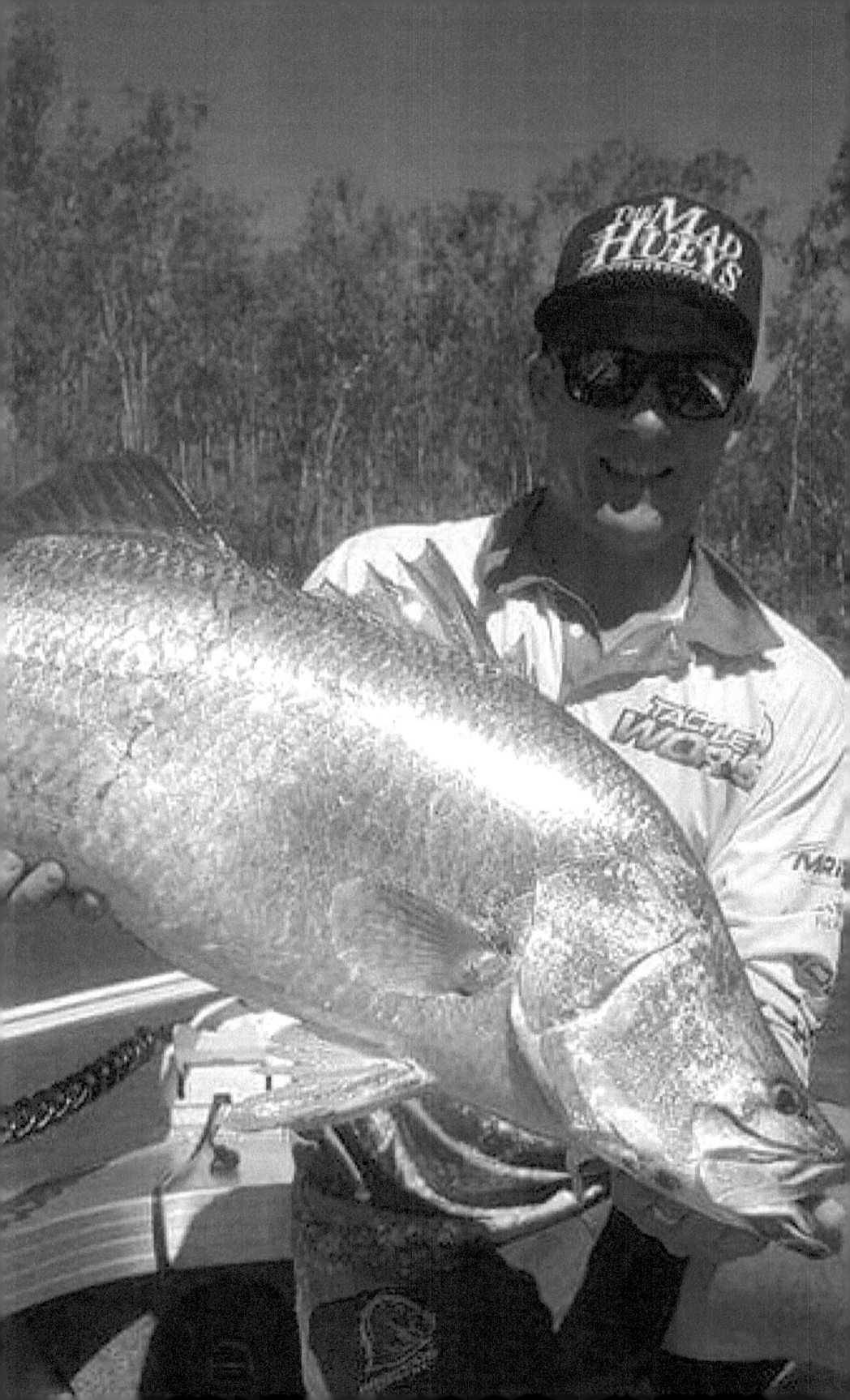

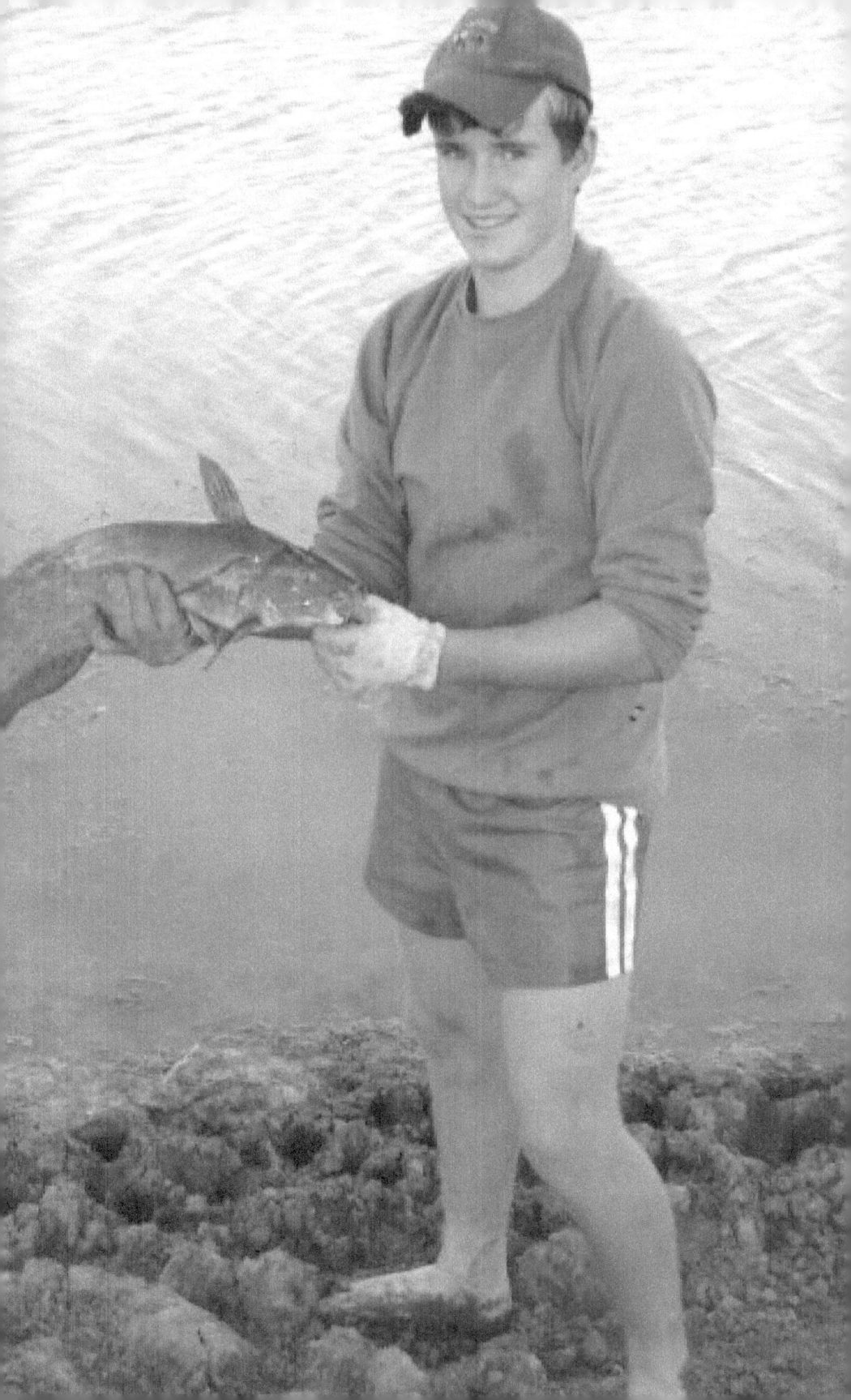

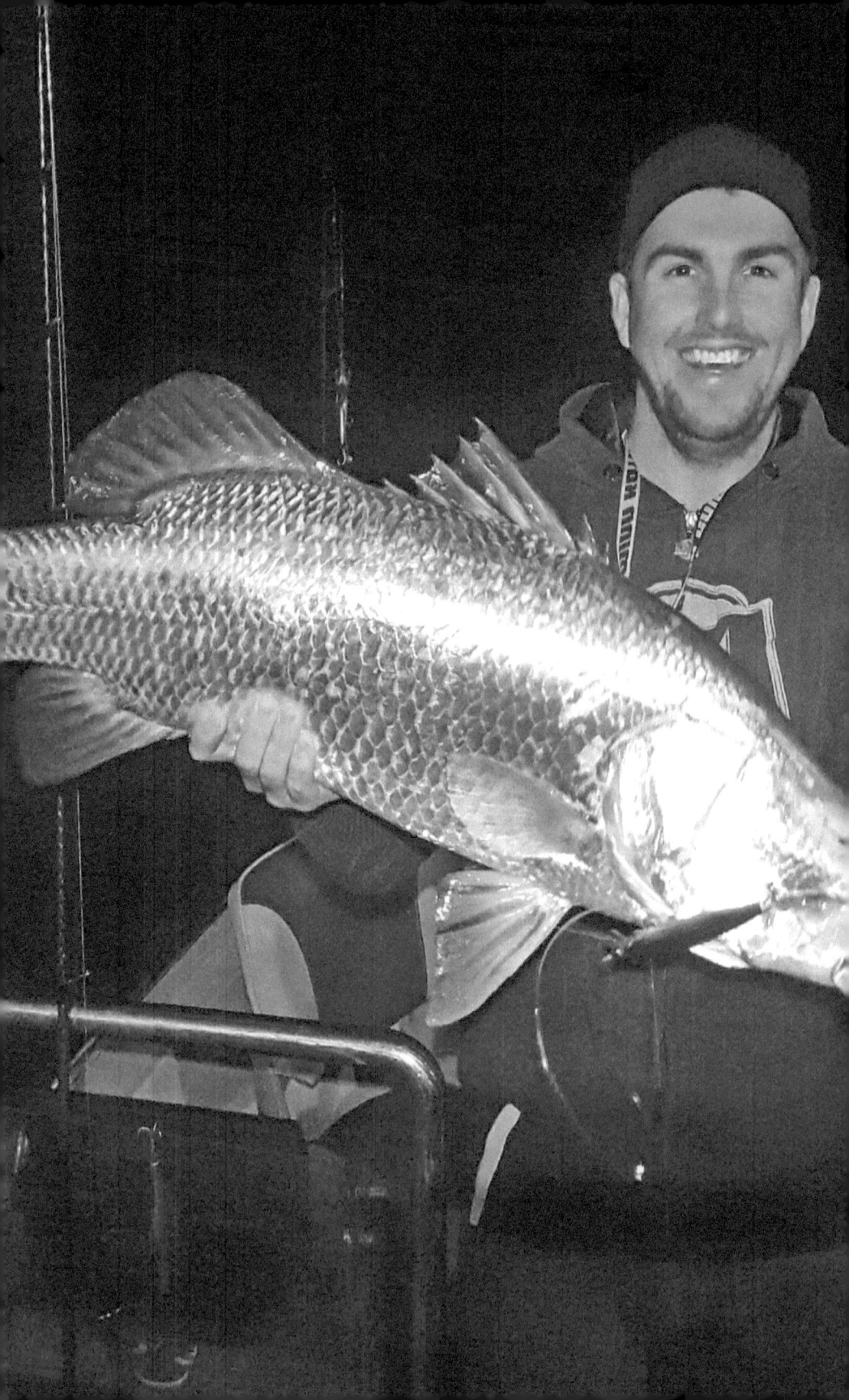

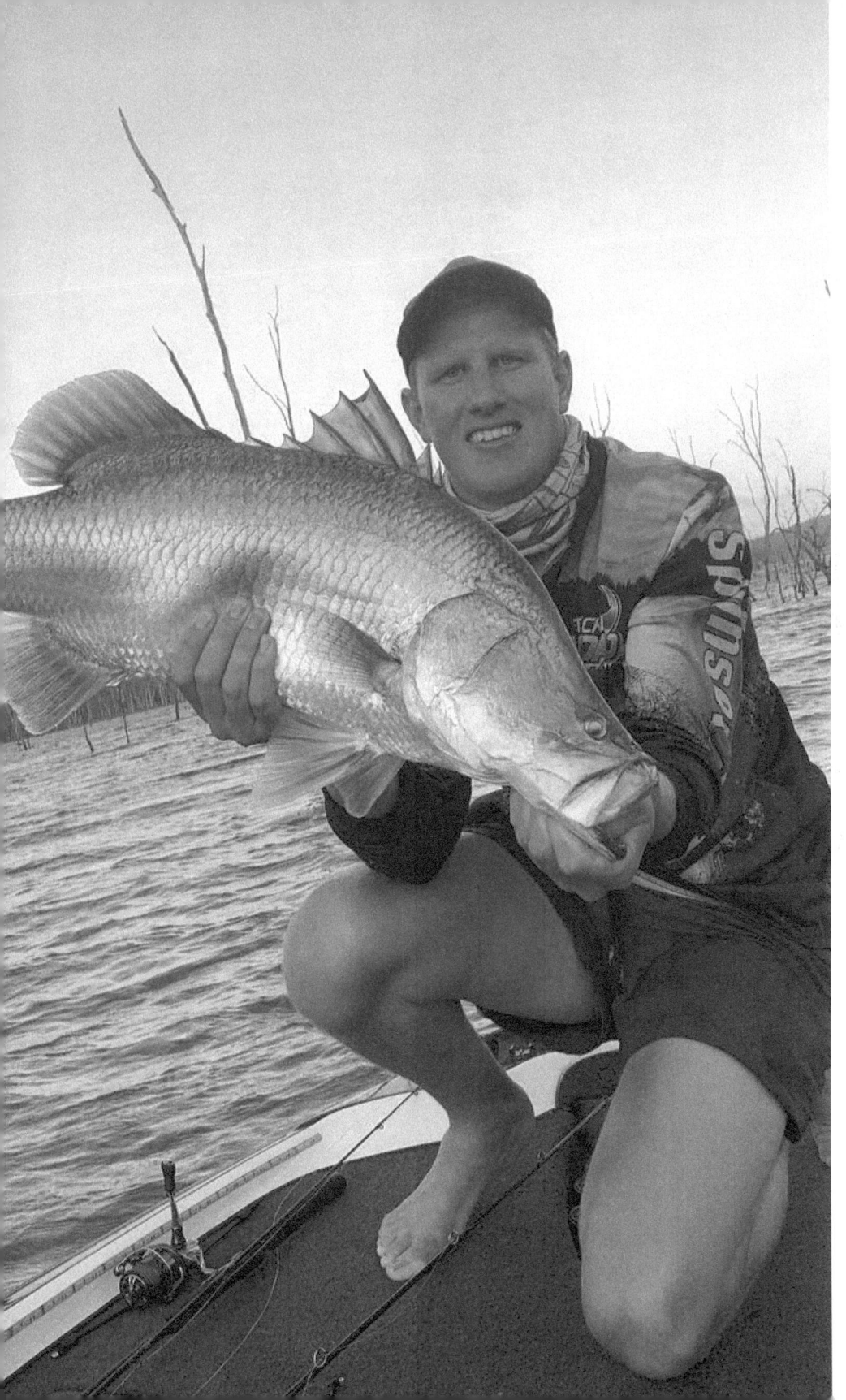

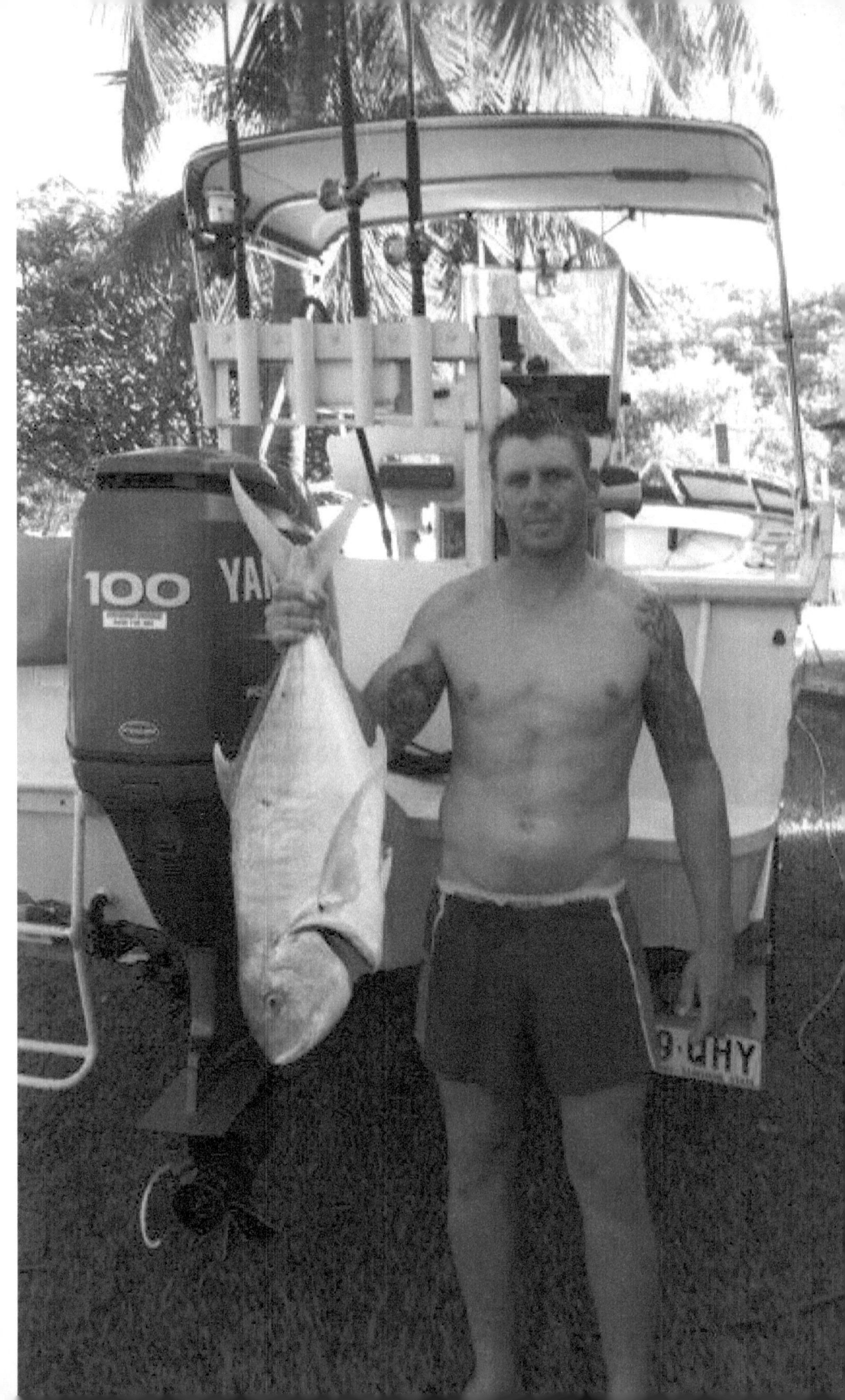

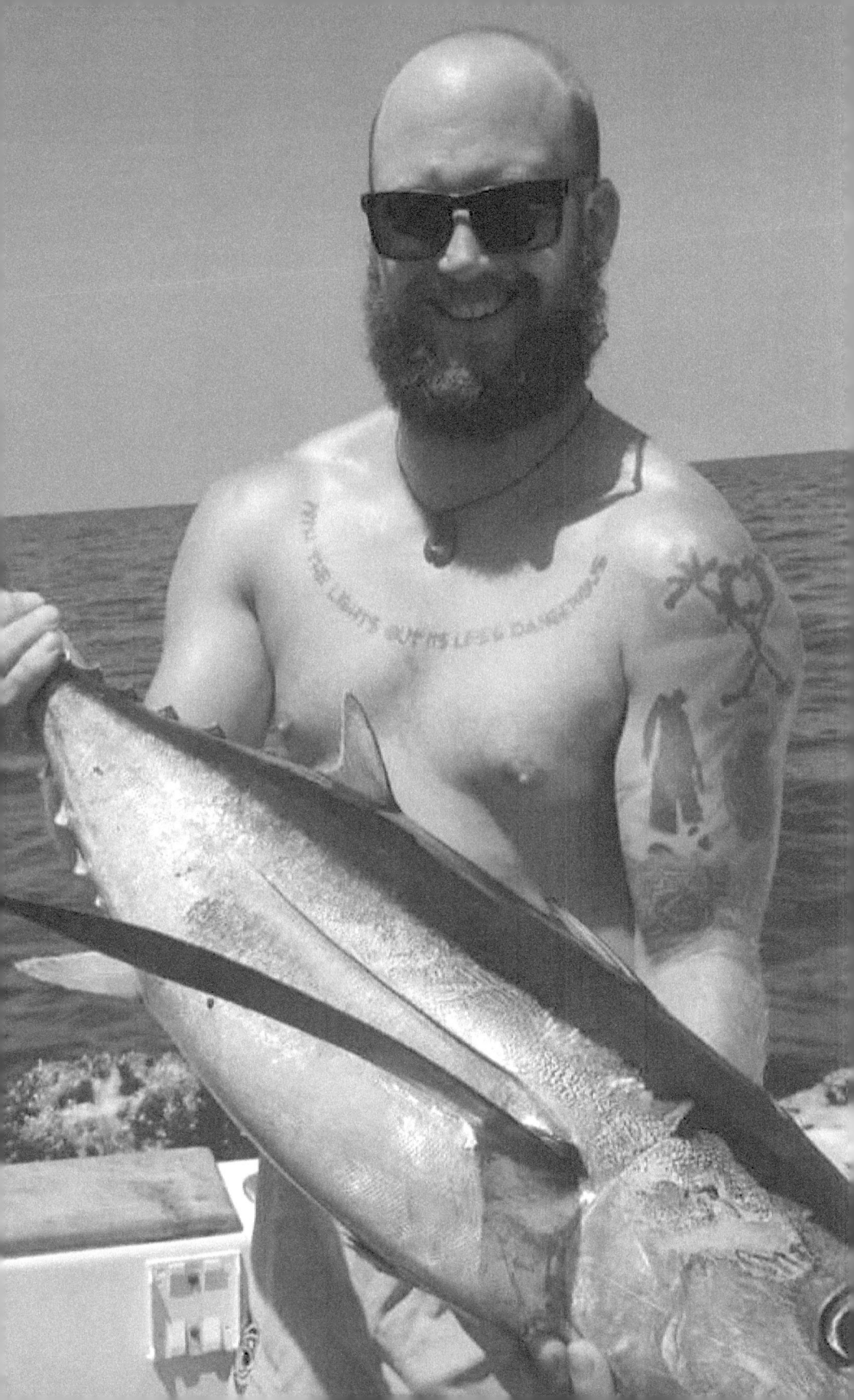

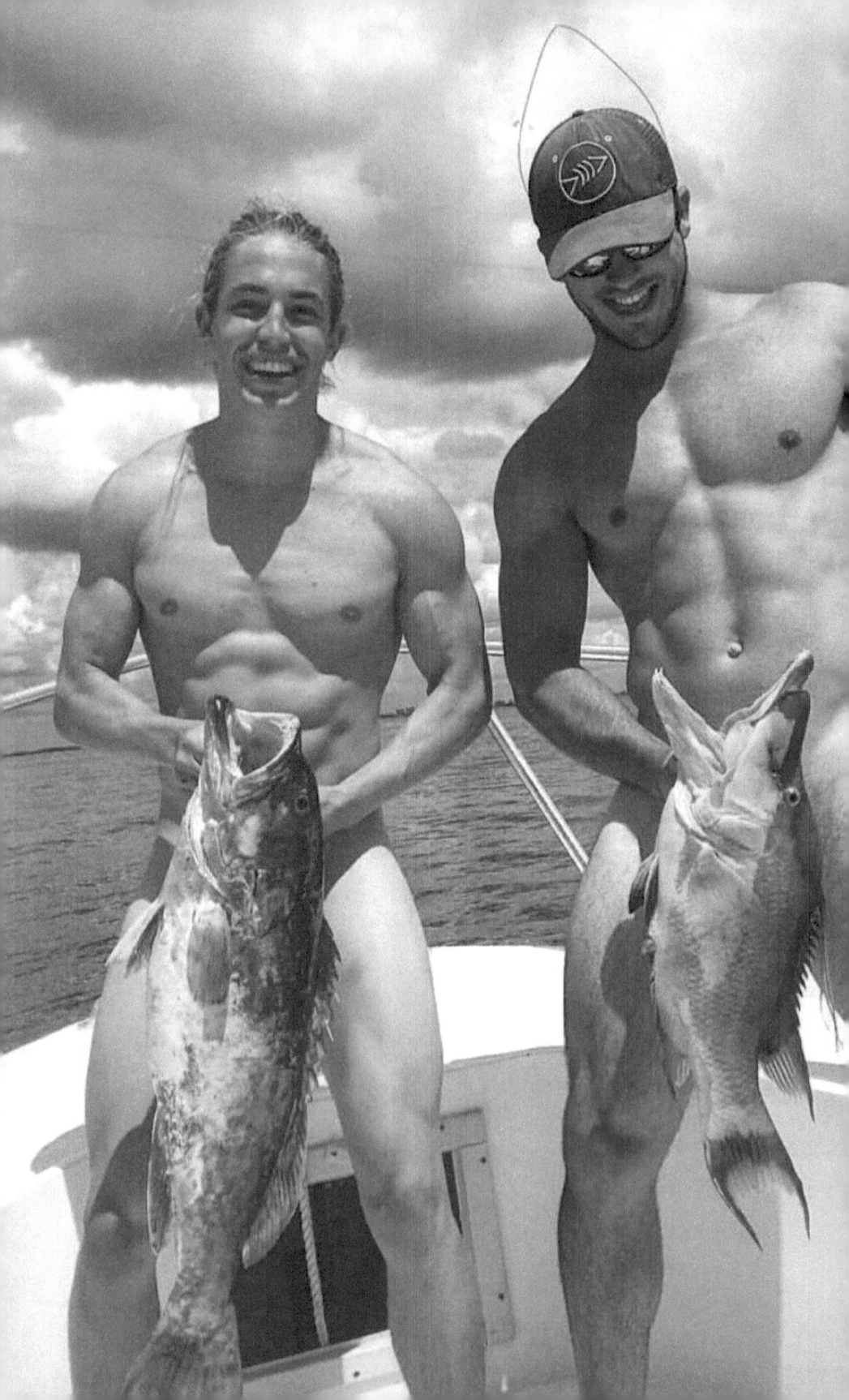

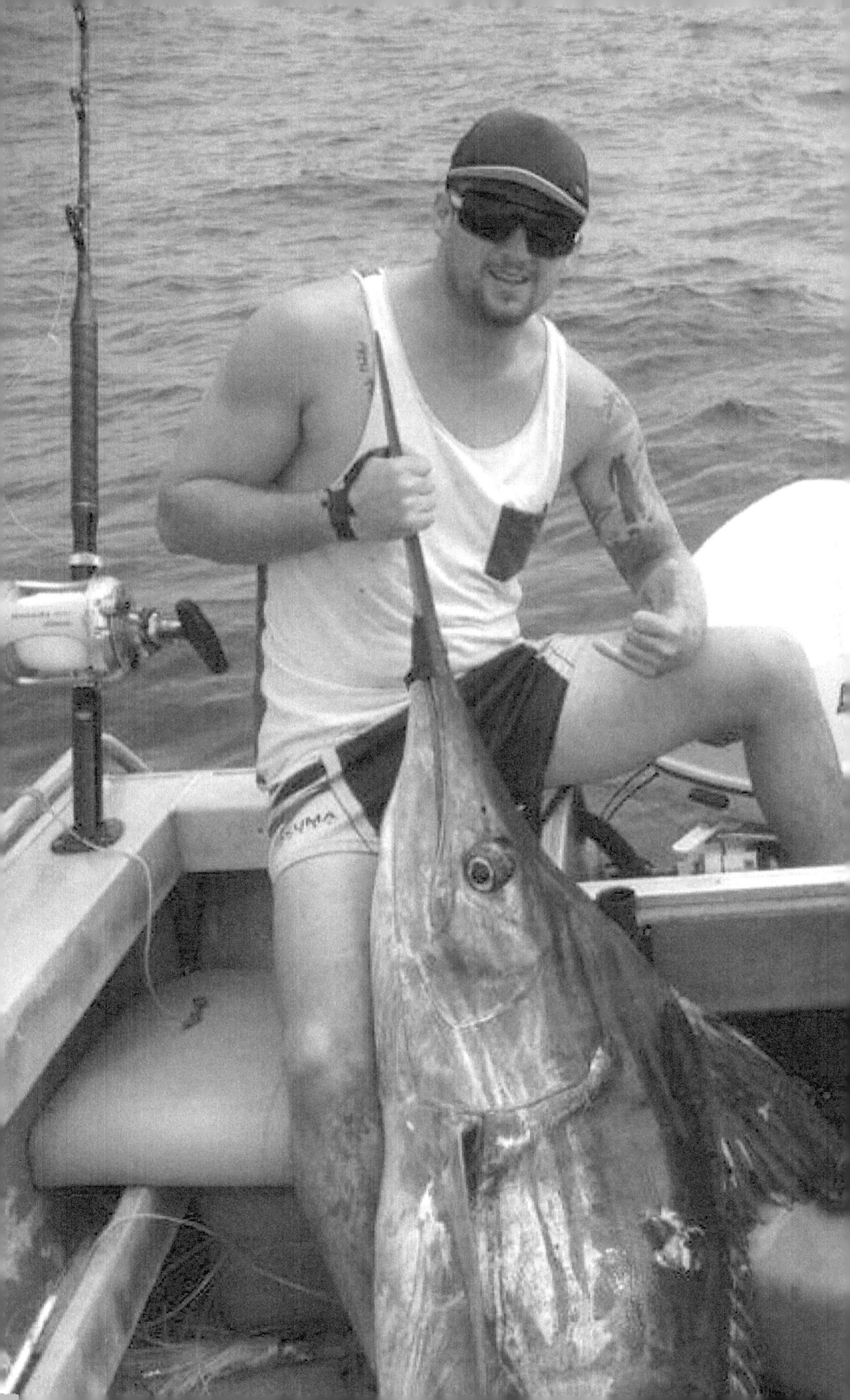

> Many men go fishing all of their lives without knowing that it is not fish they are after.
> Henry David Thoreau

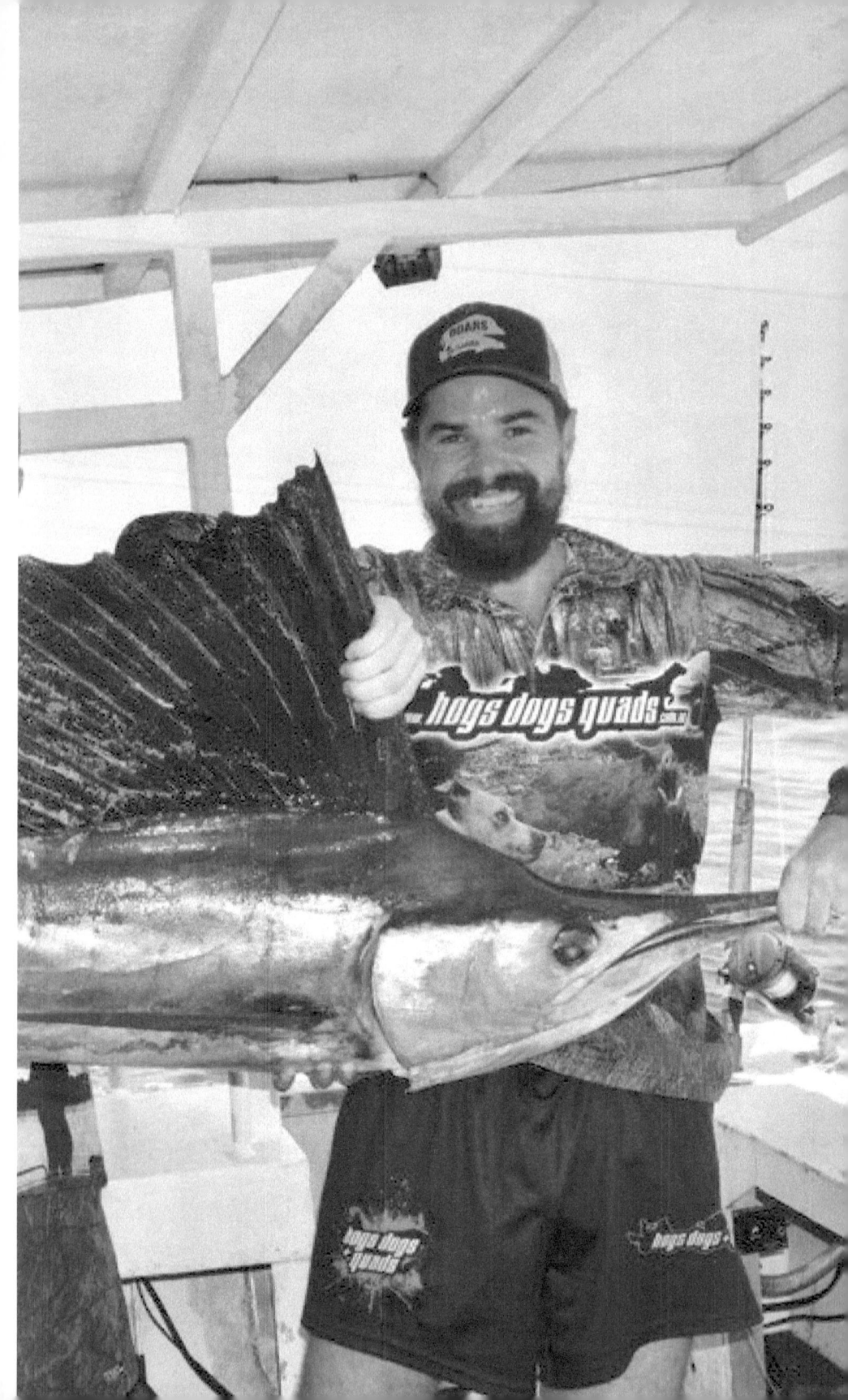

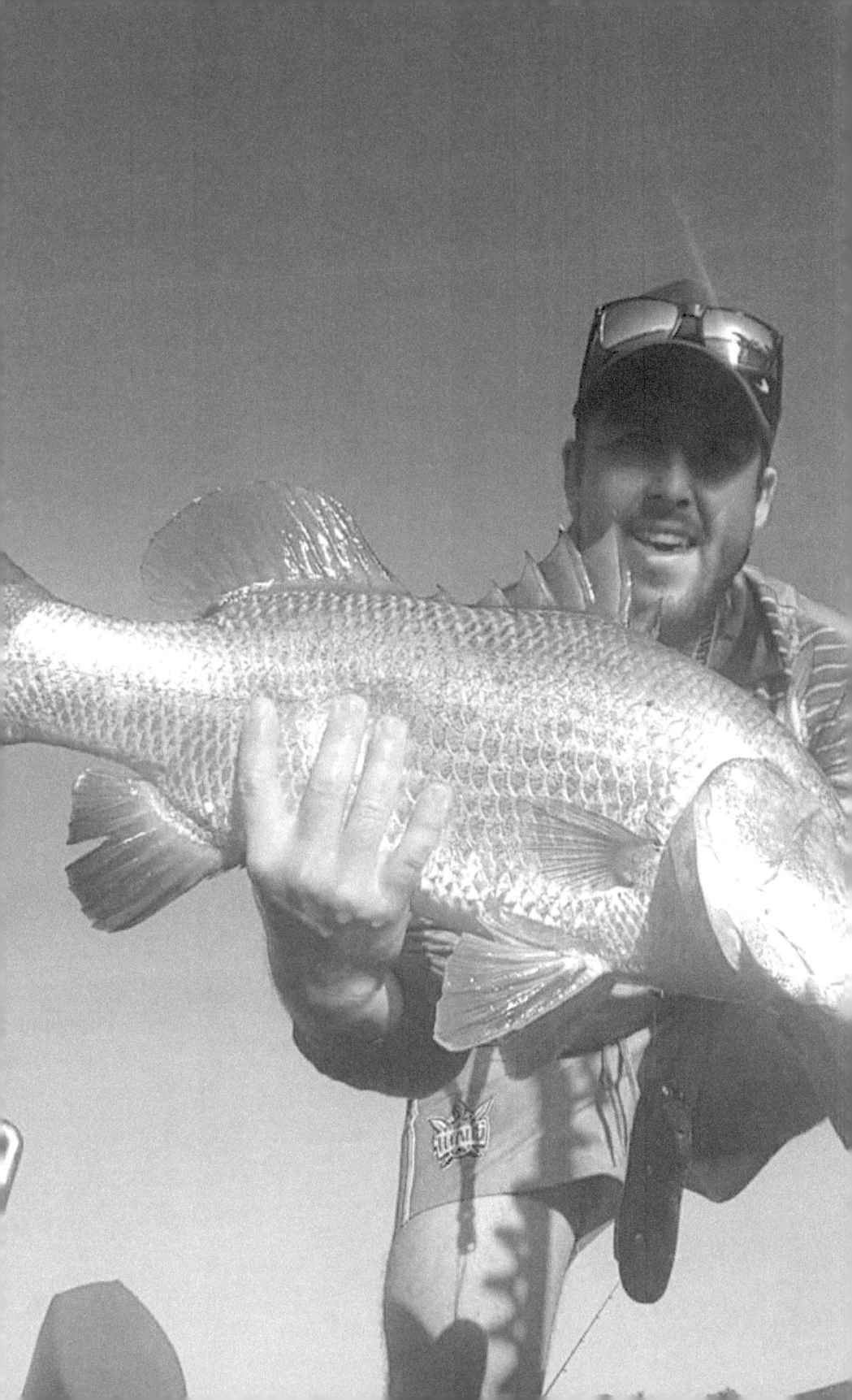

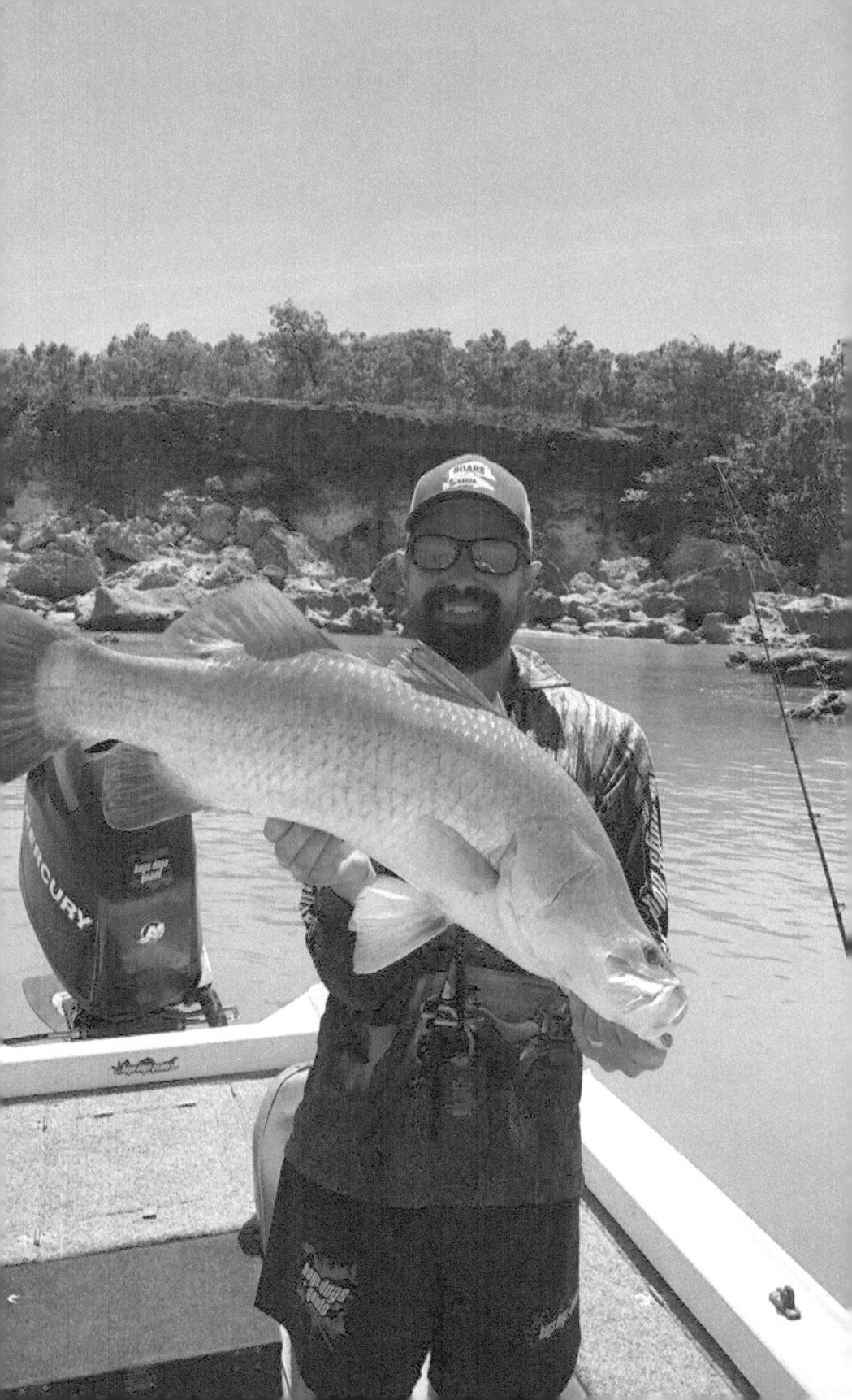

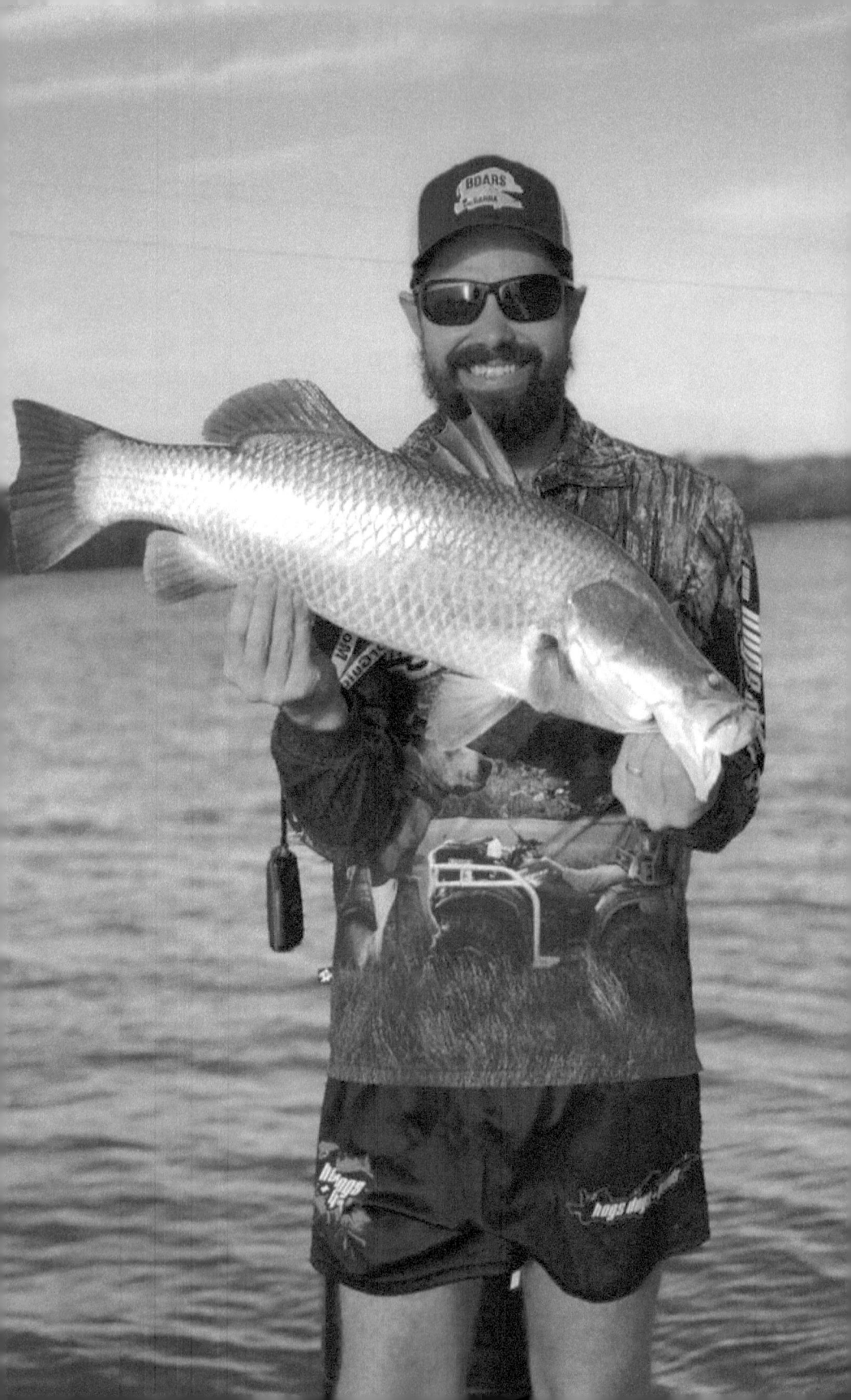

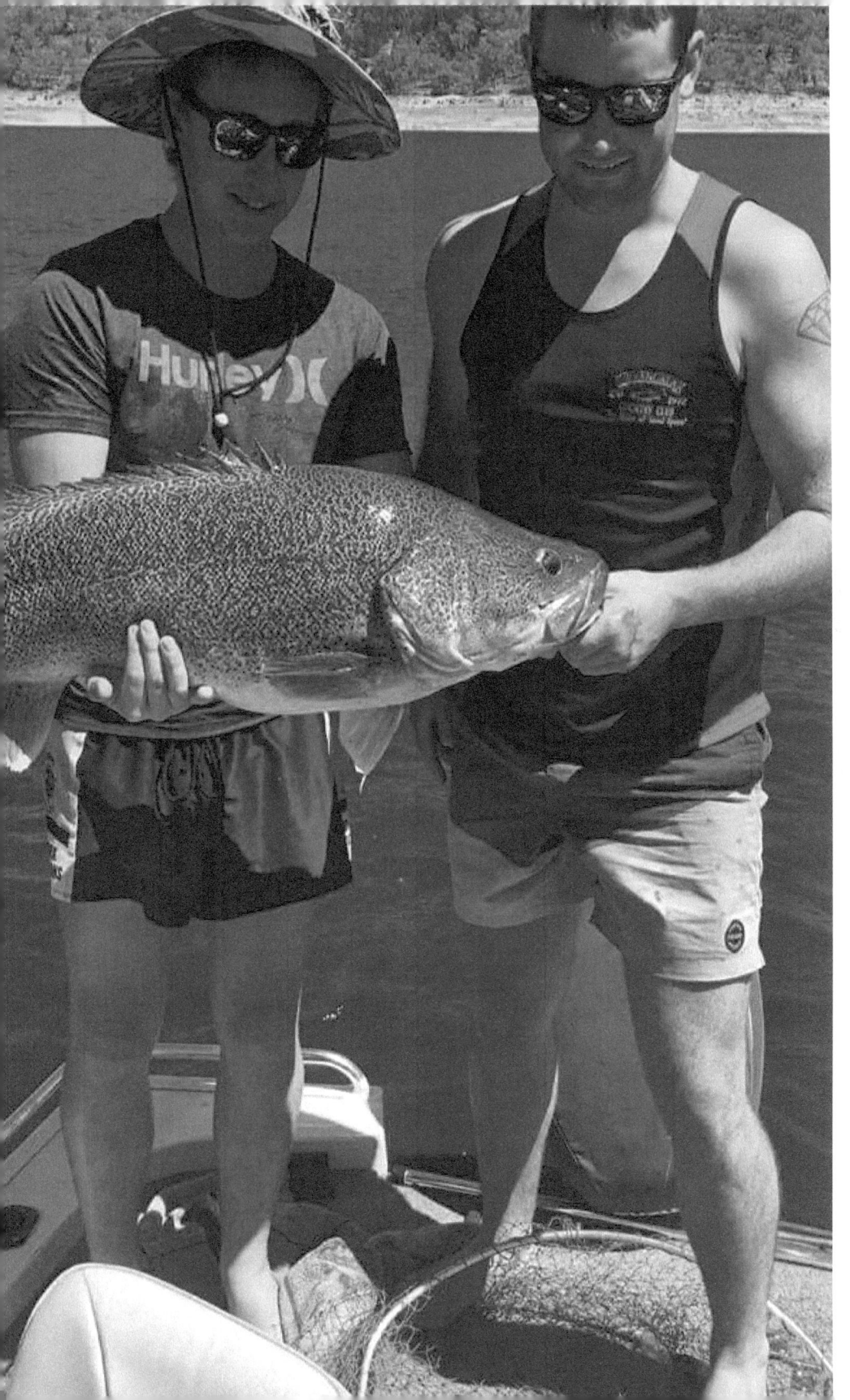

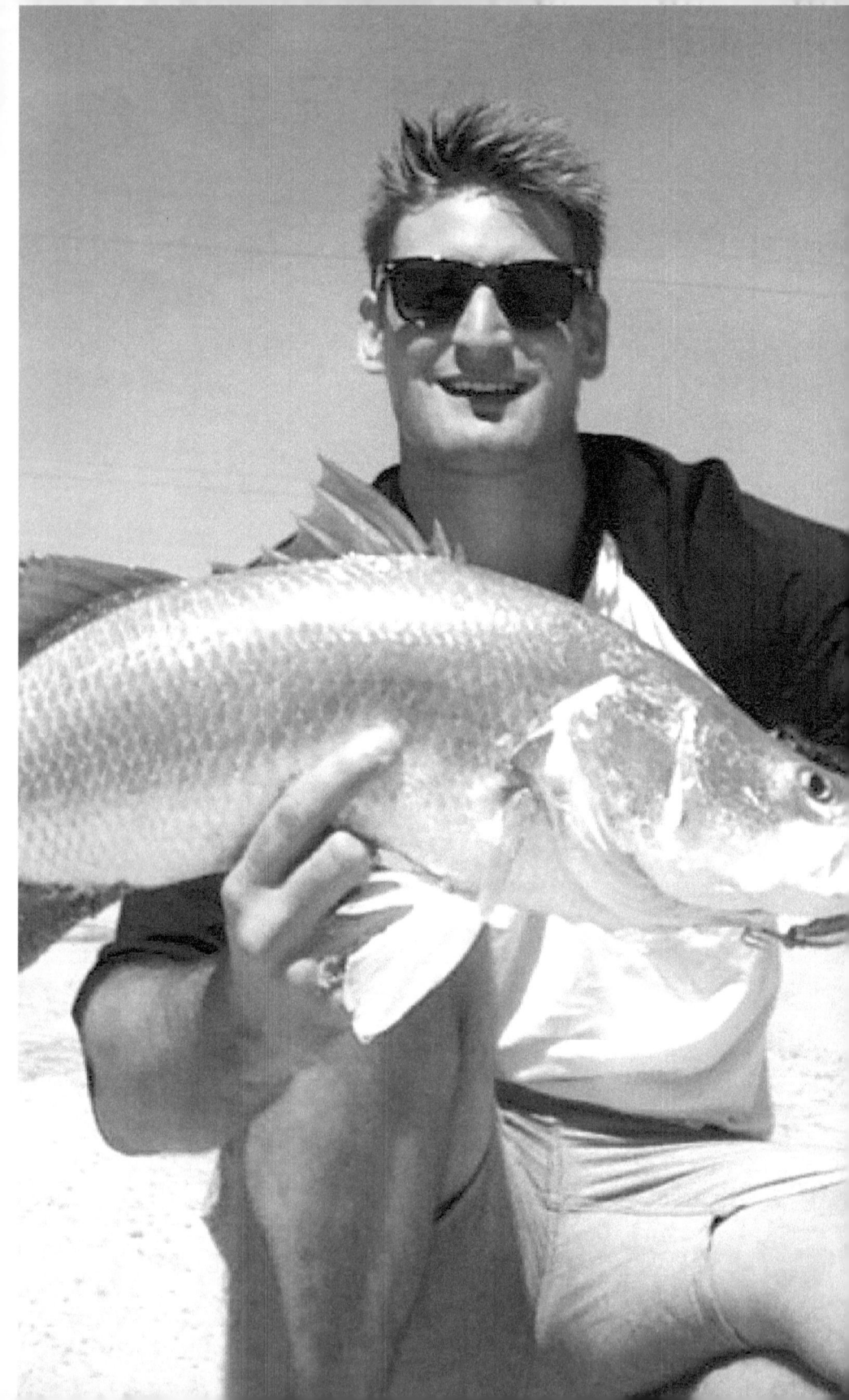

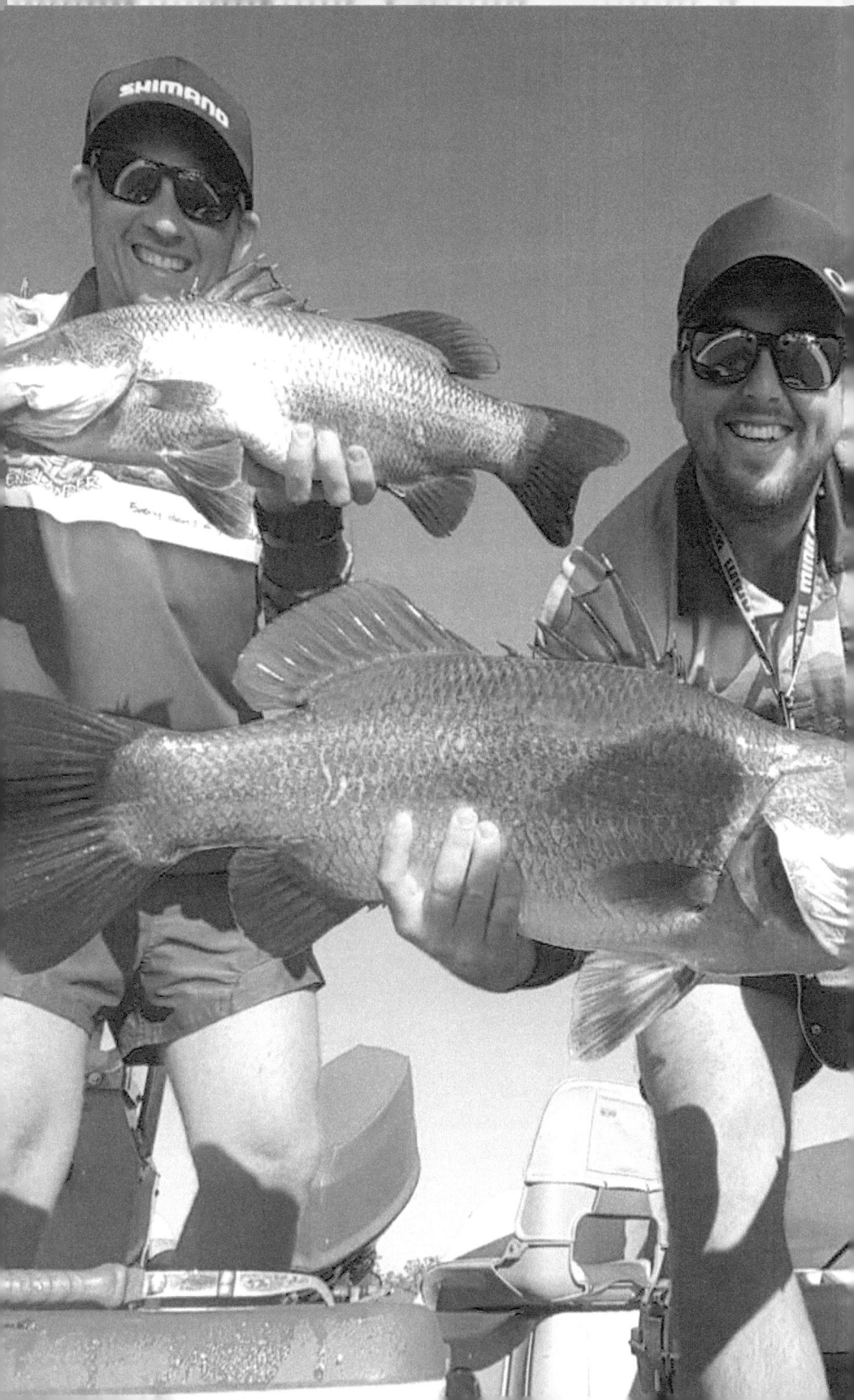

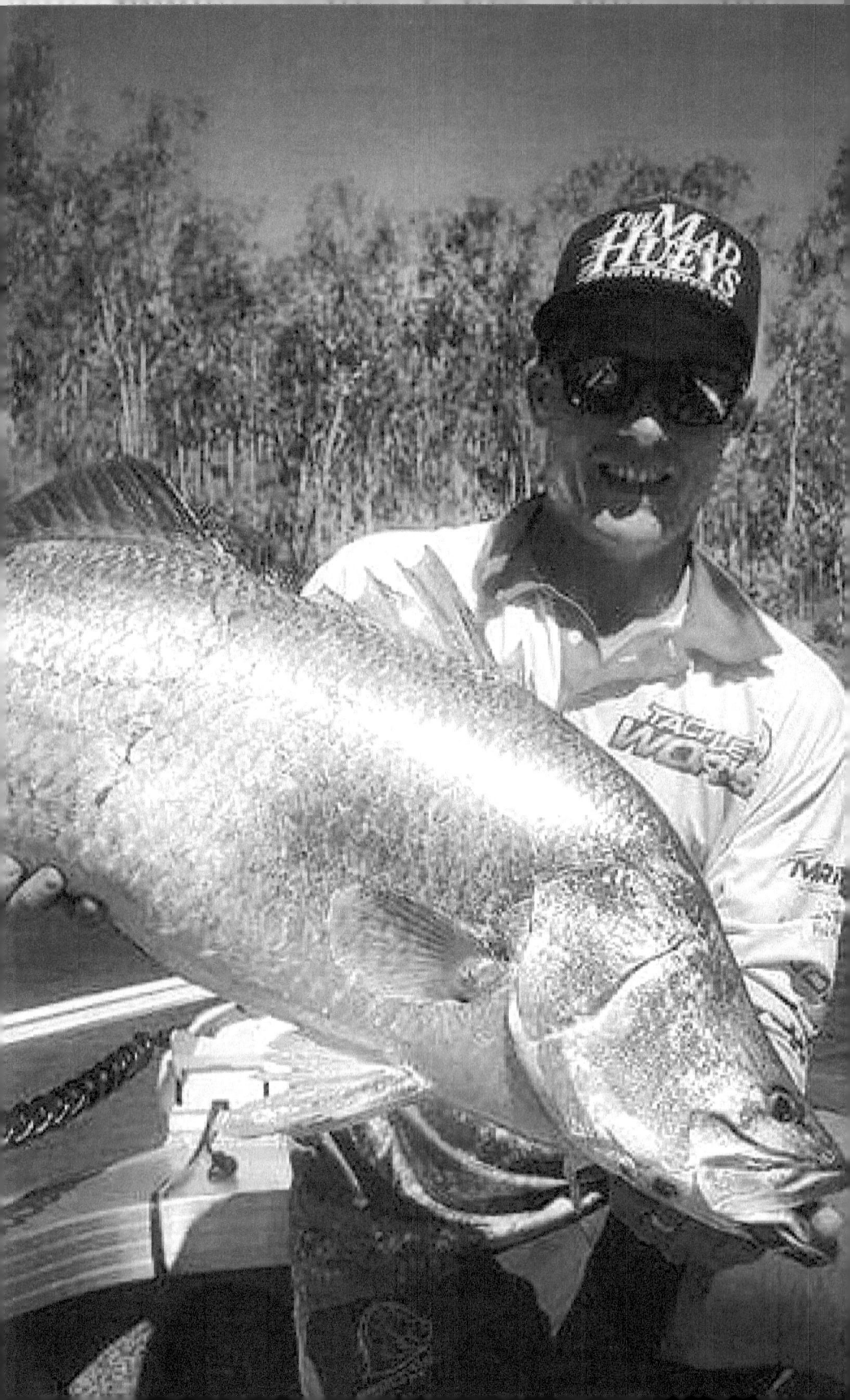

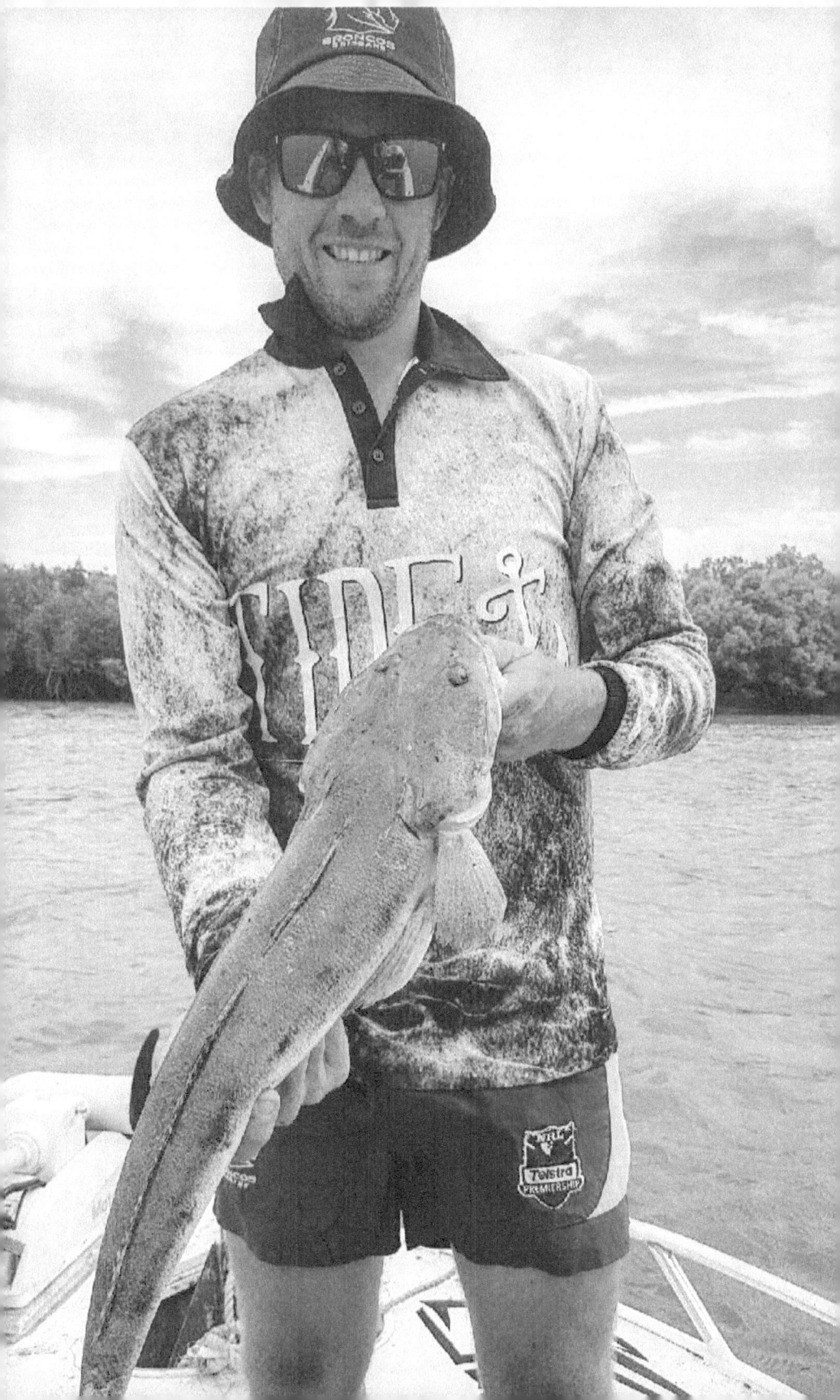

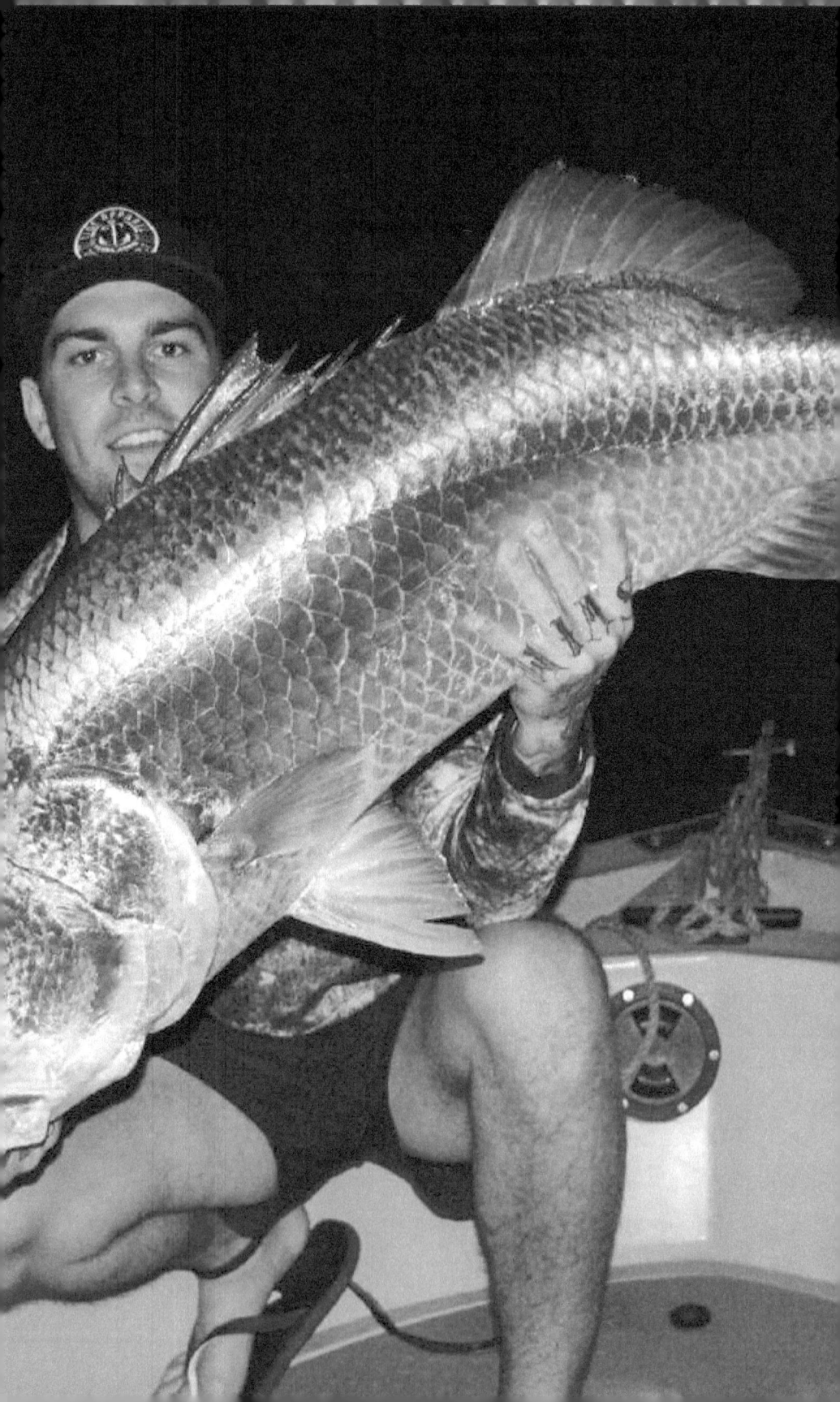

There's a fine line between fishing and just standing on the shore like an idiot.
Steven Wright

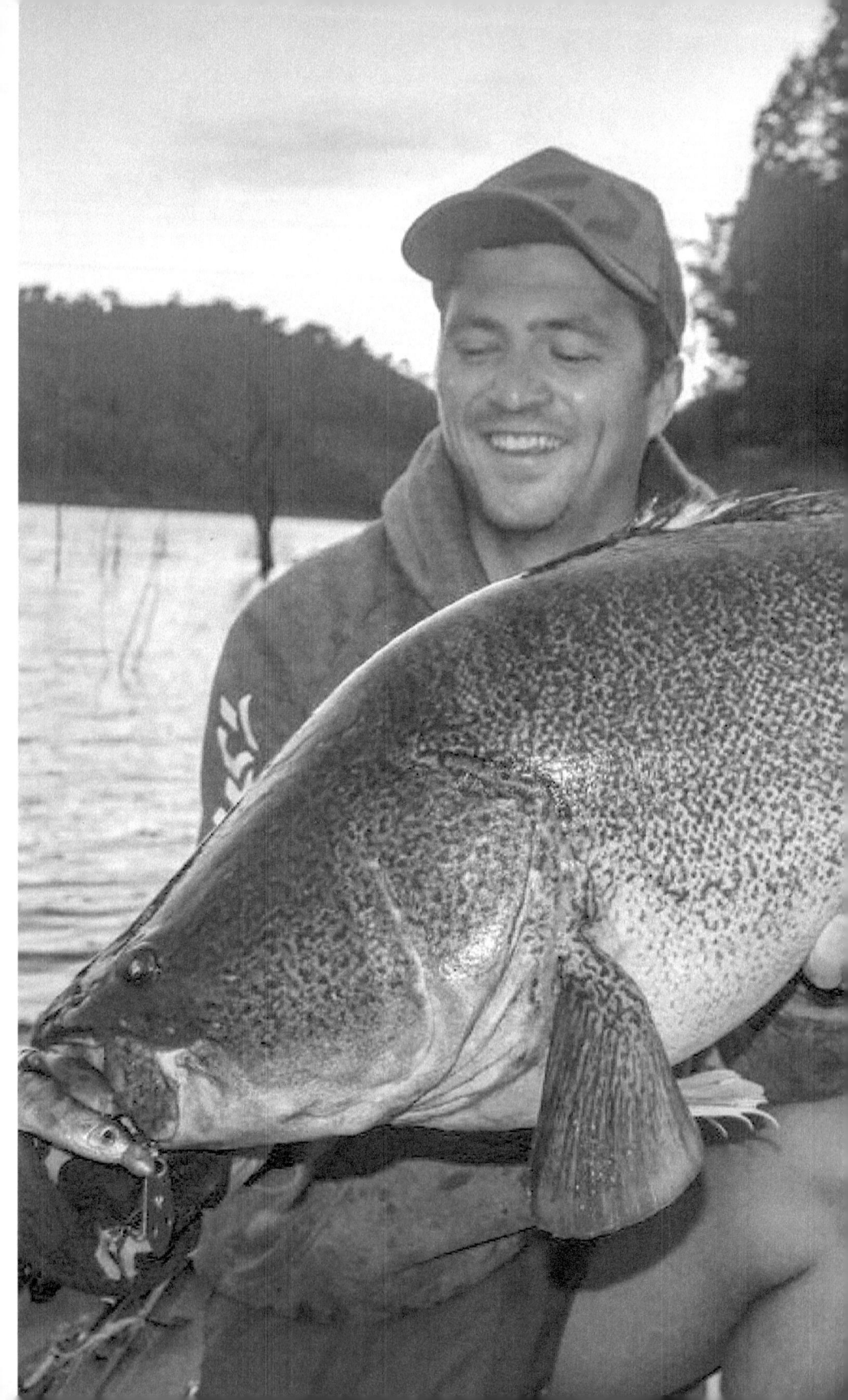

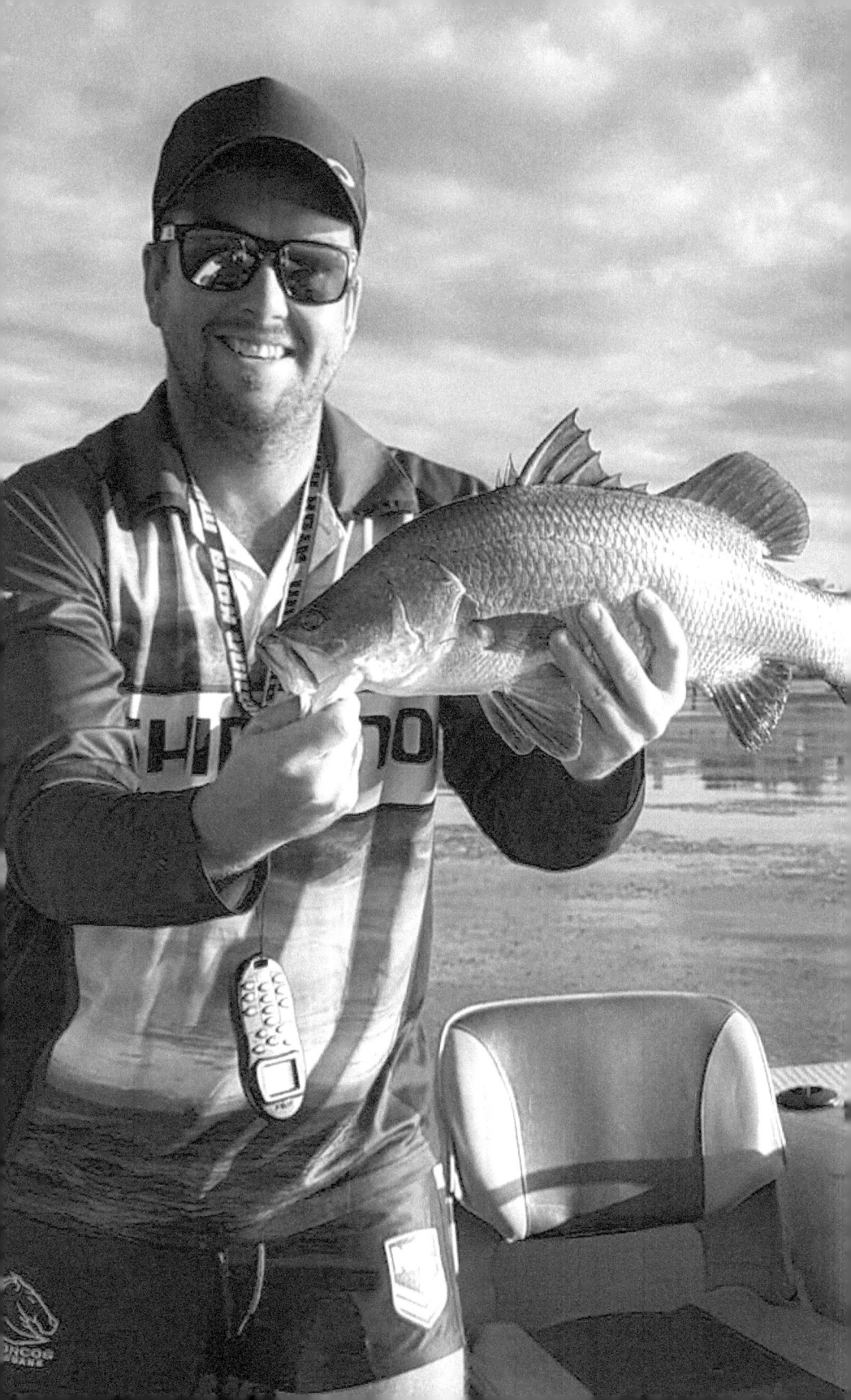

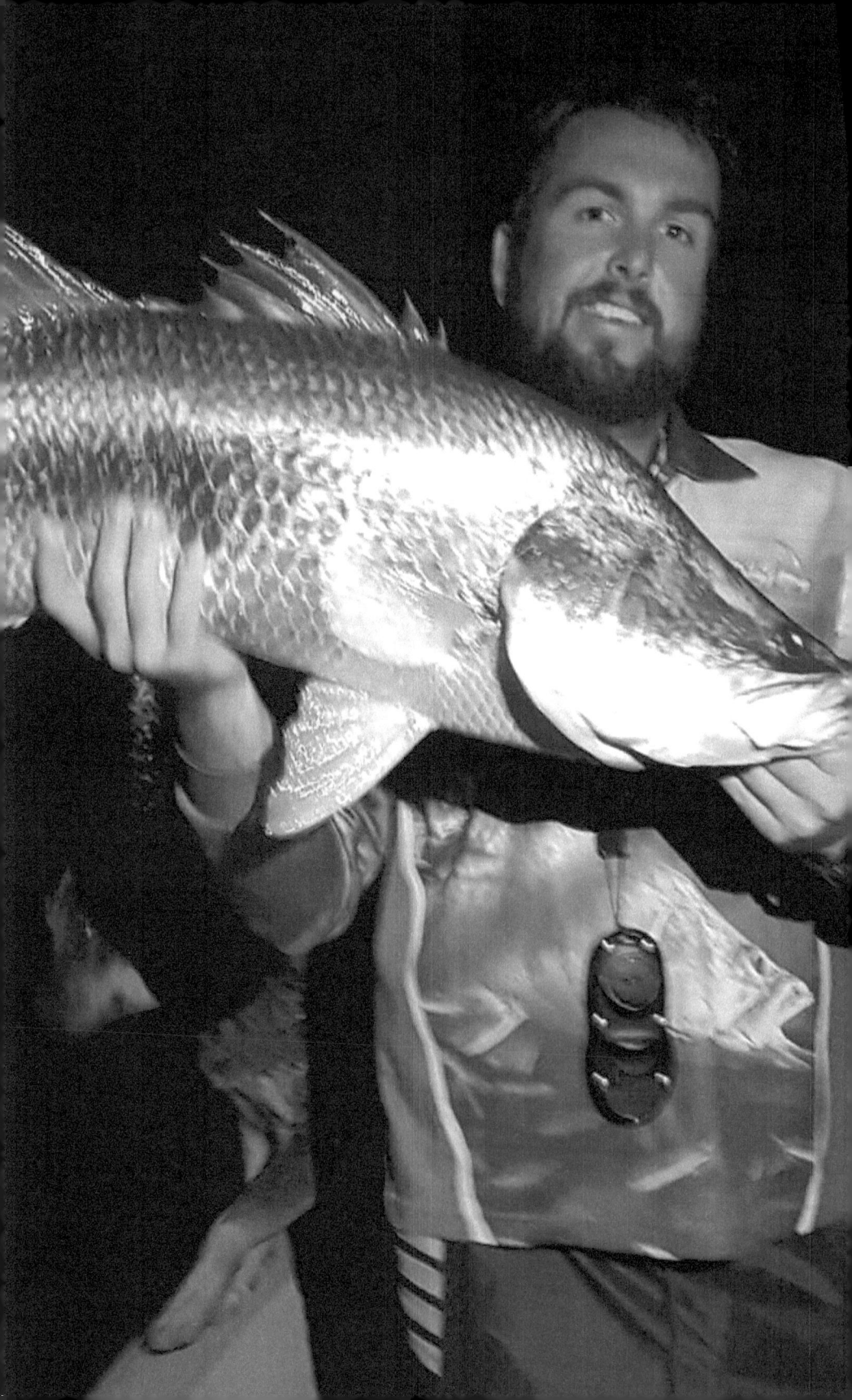

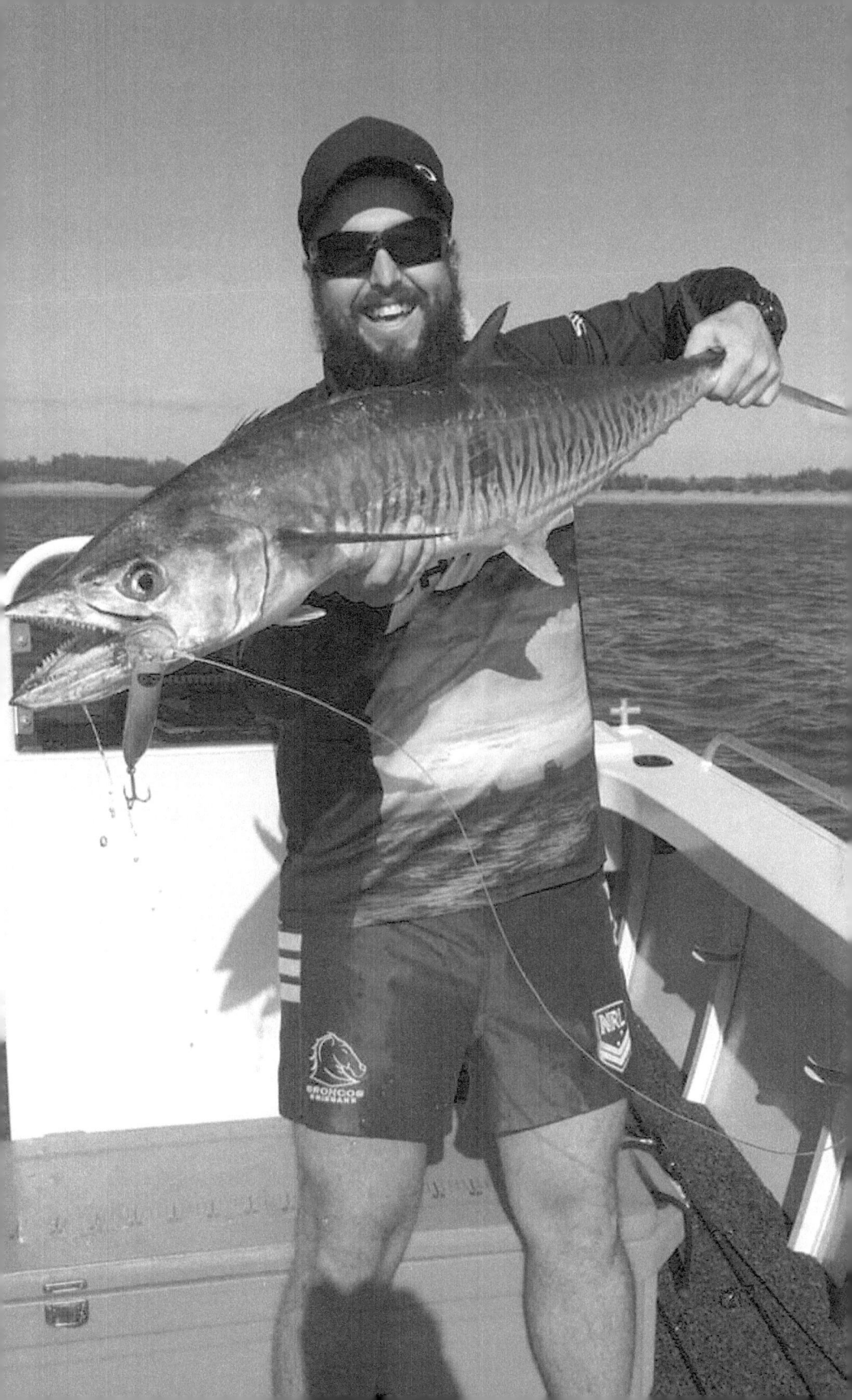

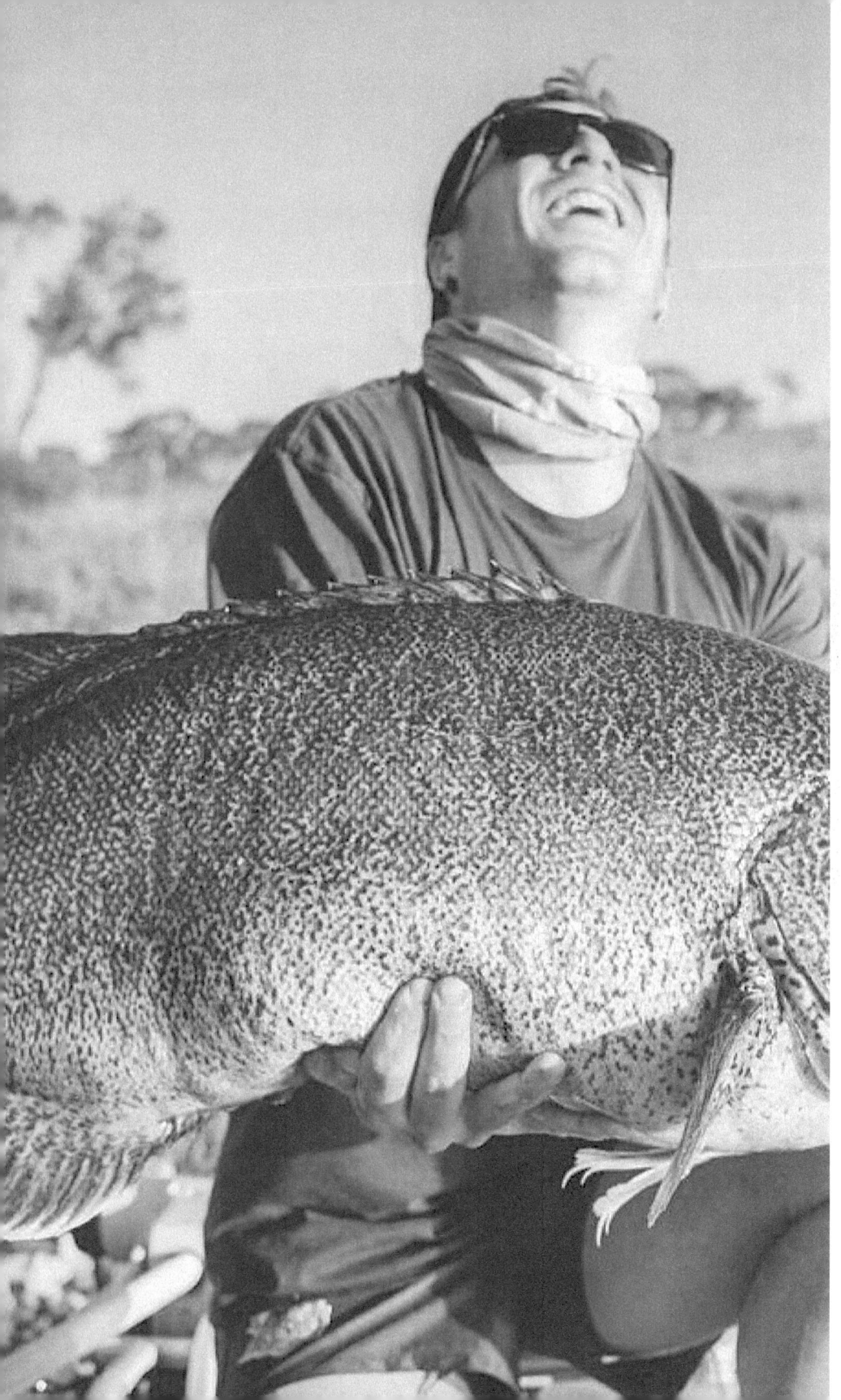

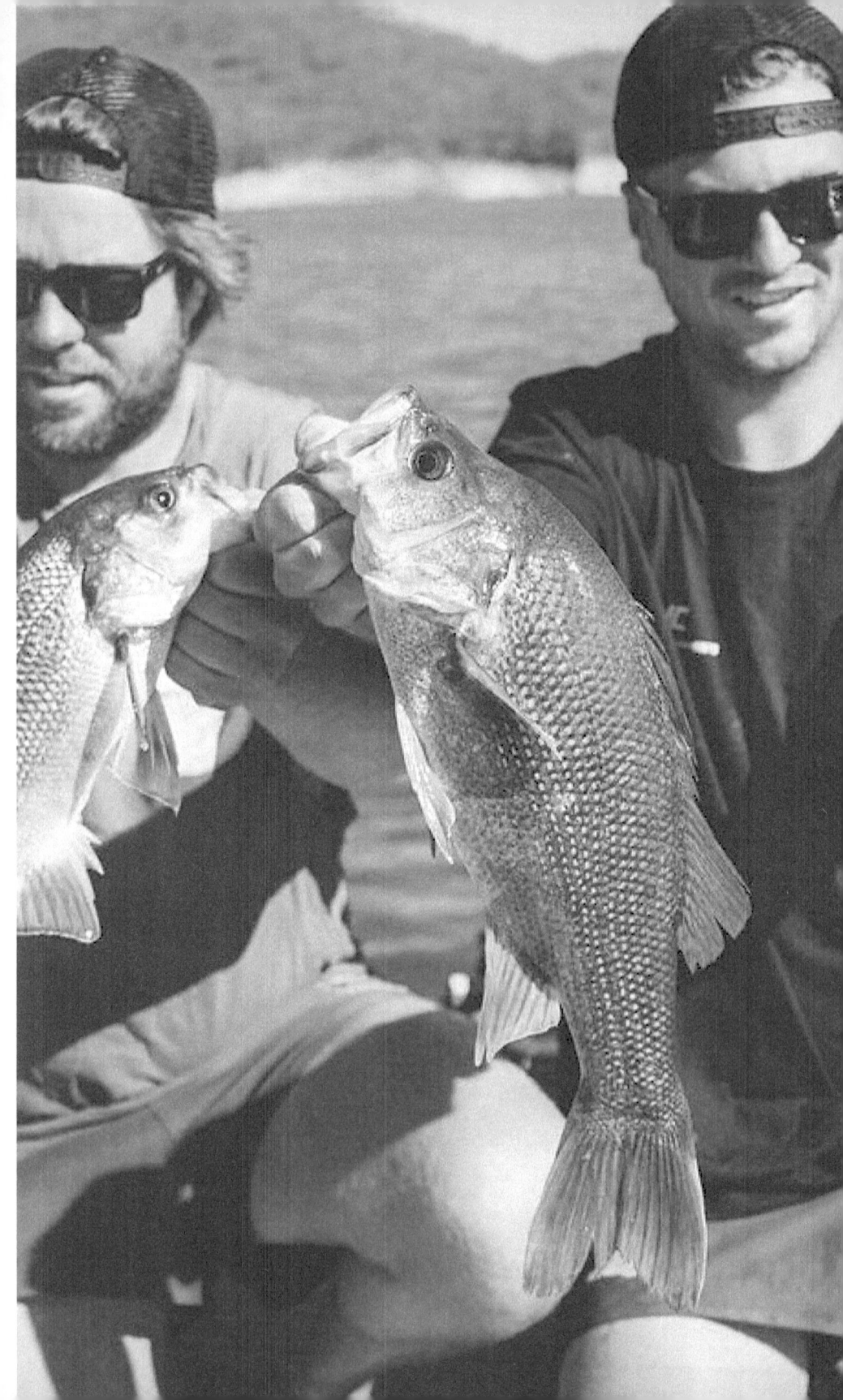

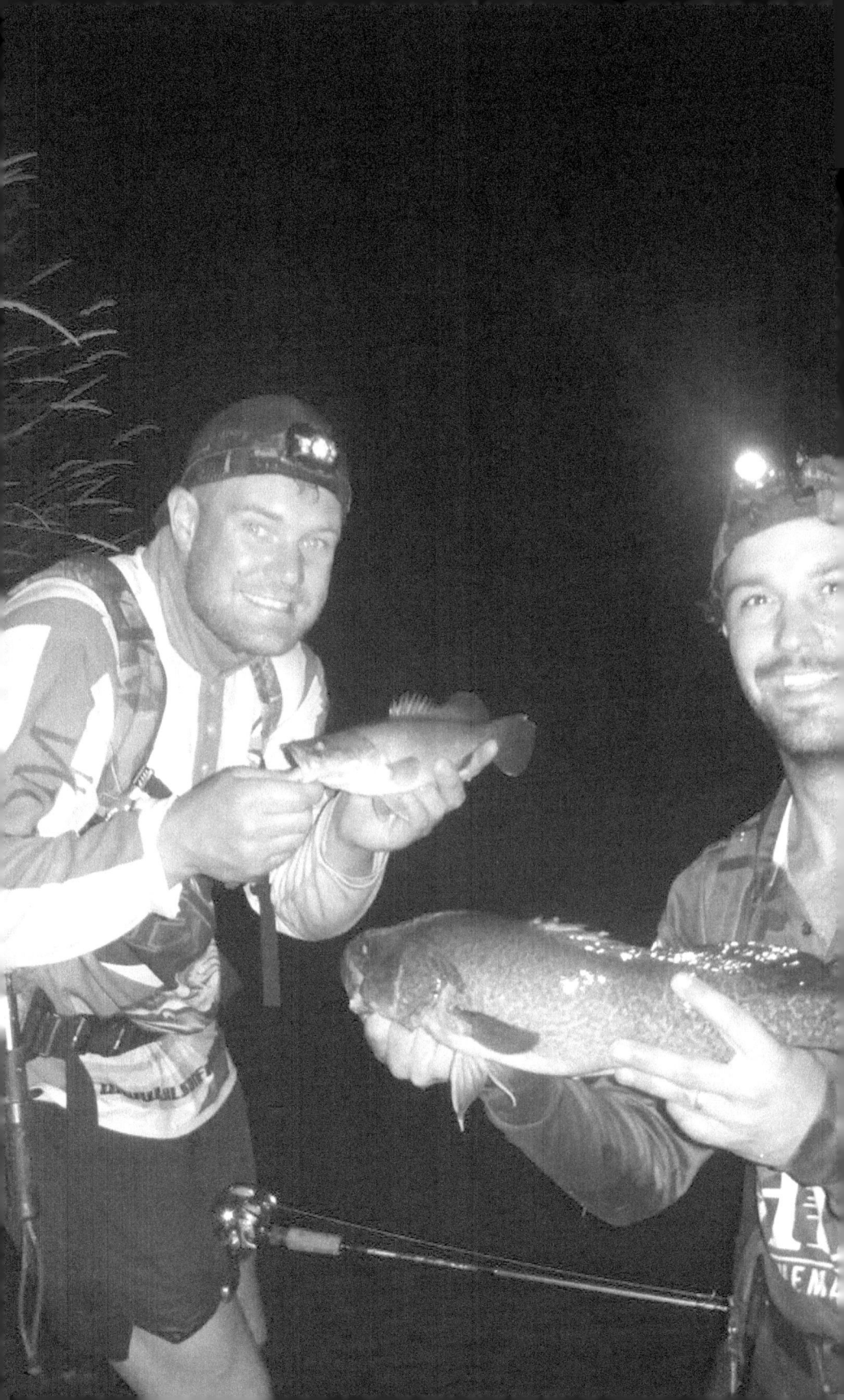

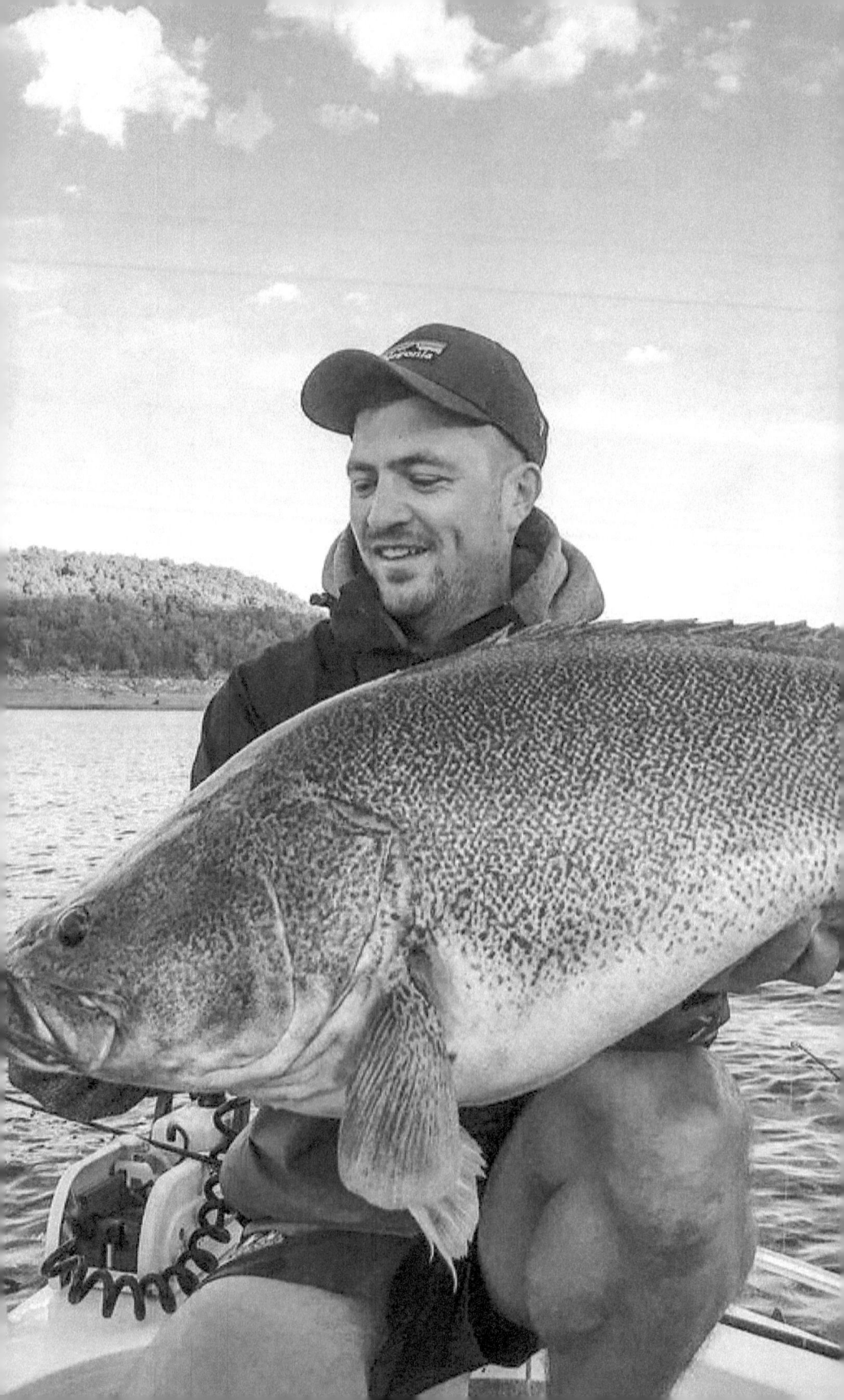

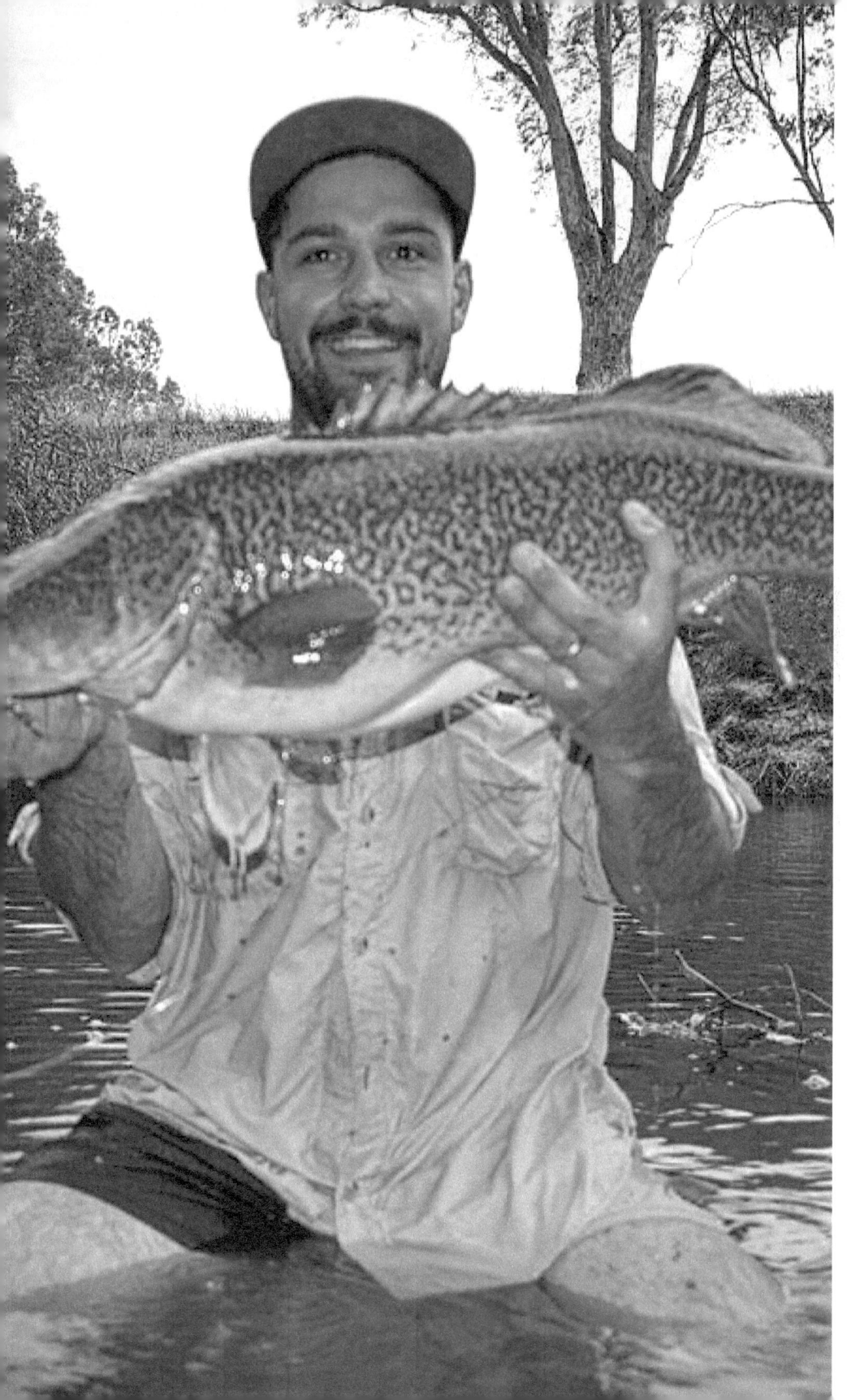

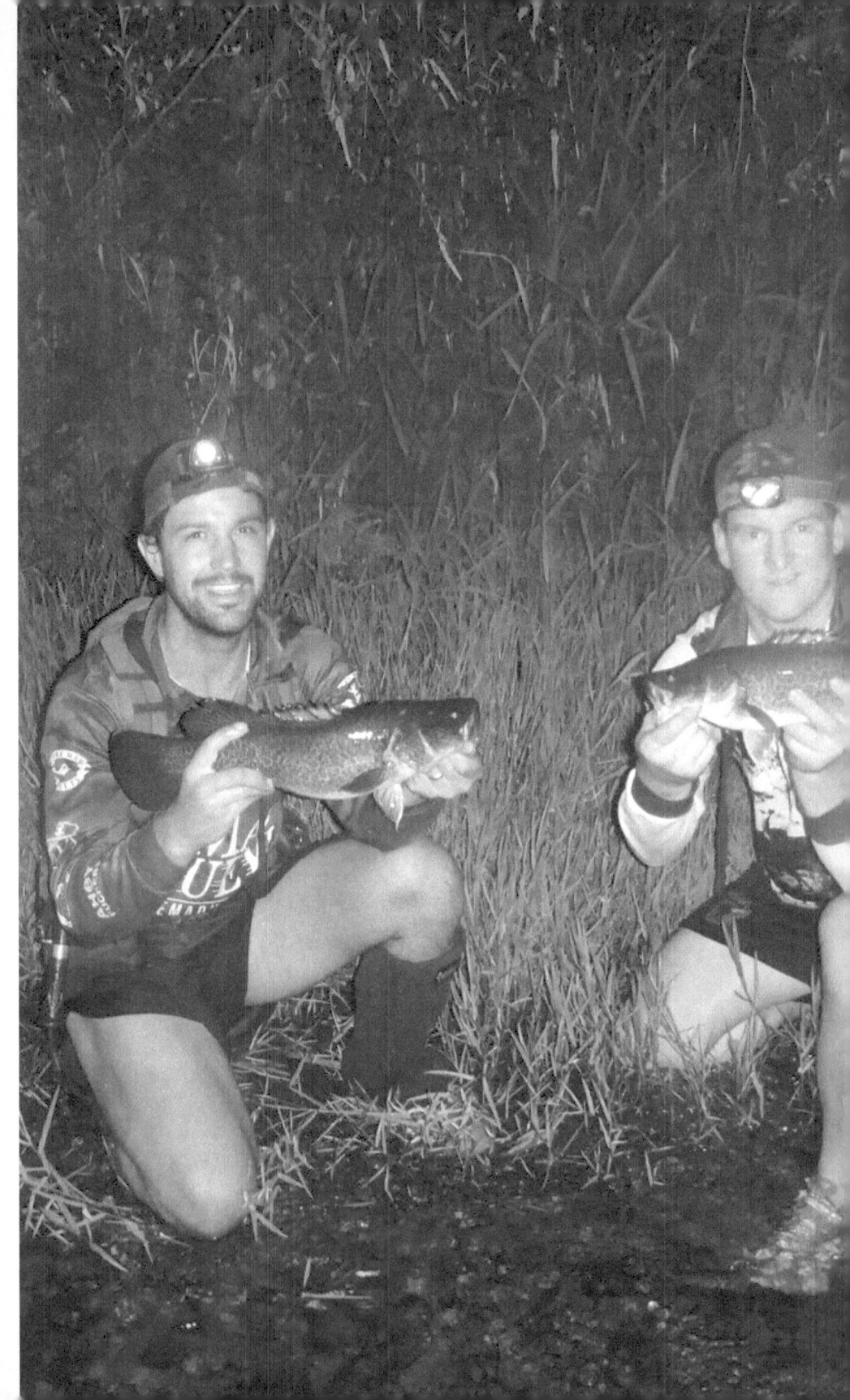

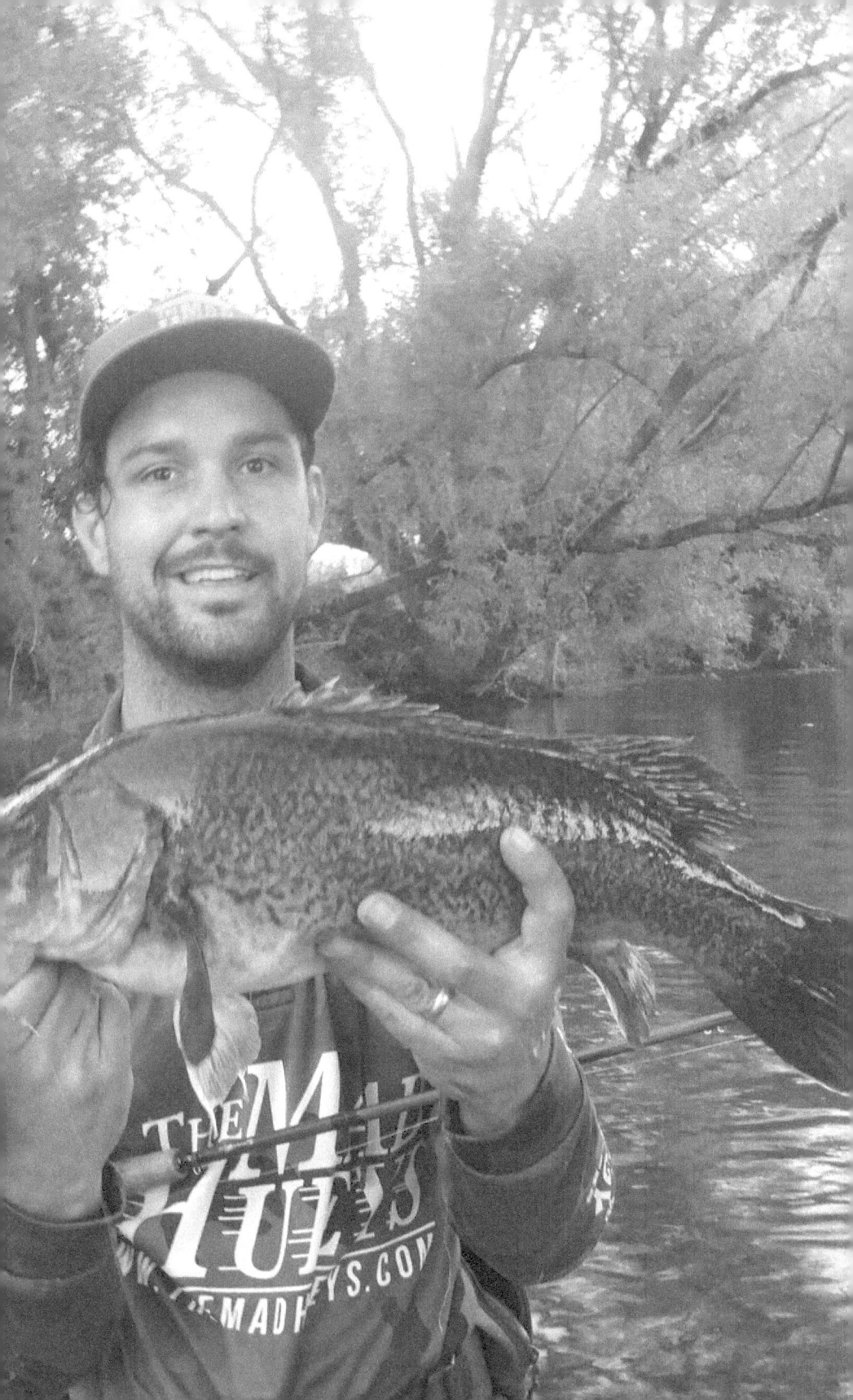

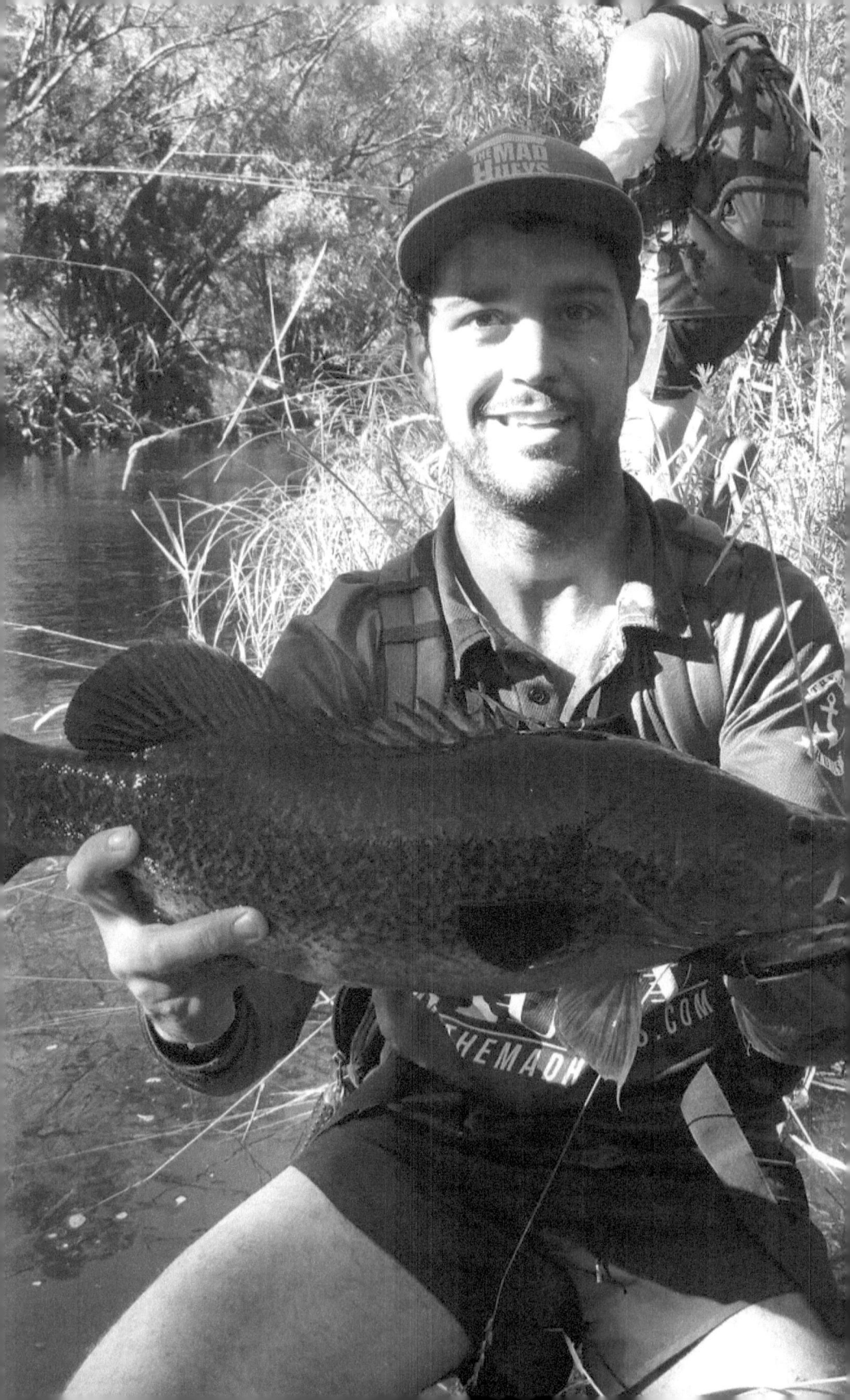

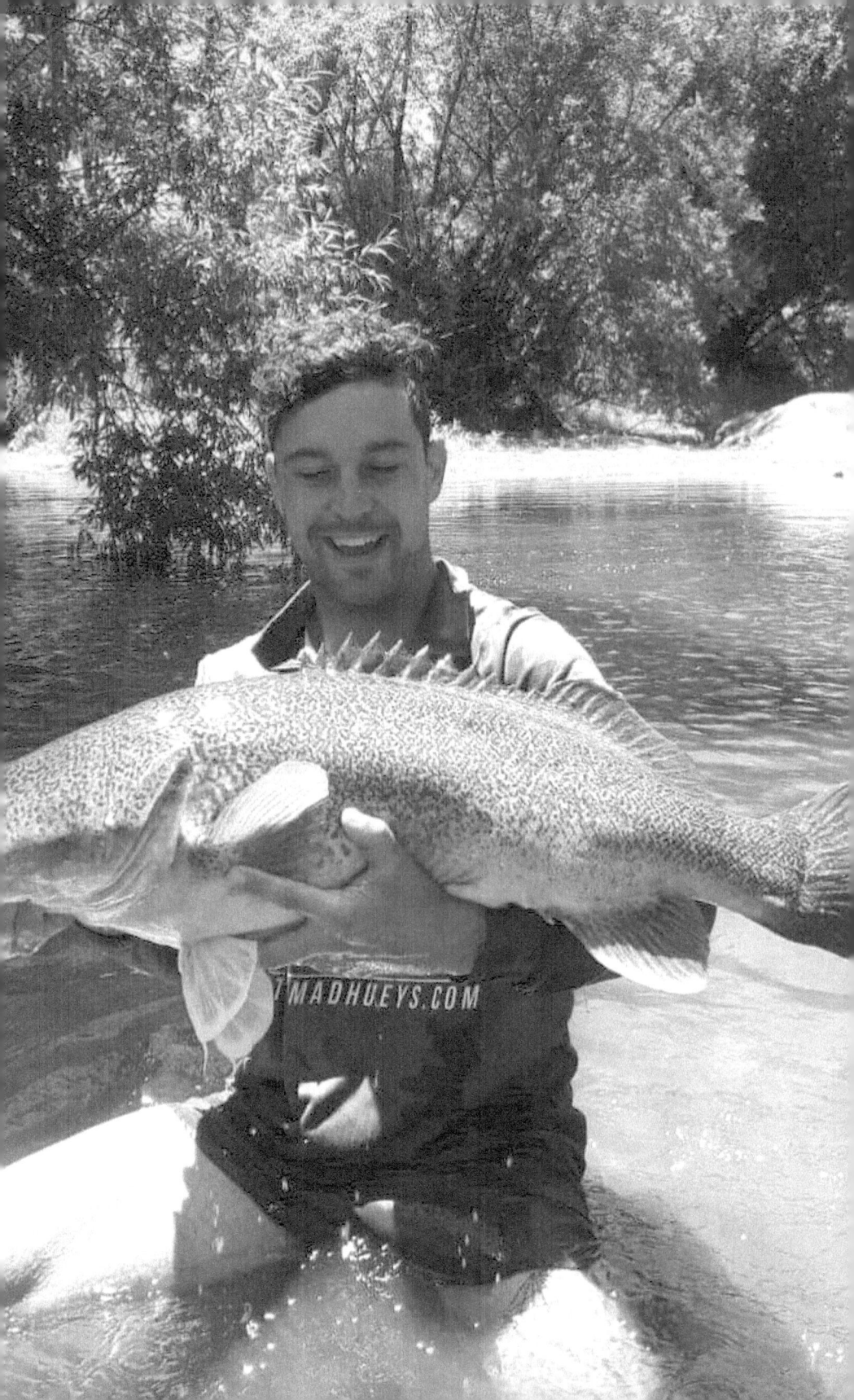

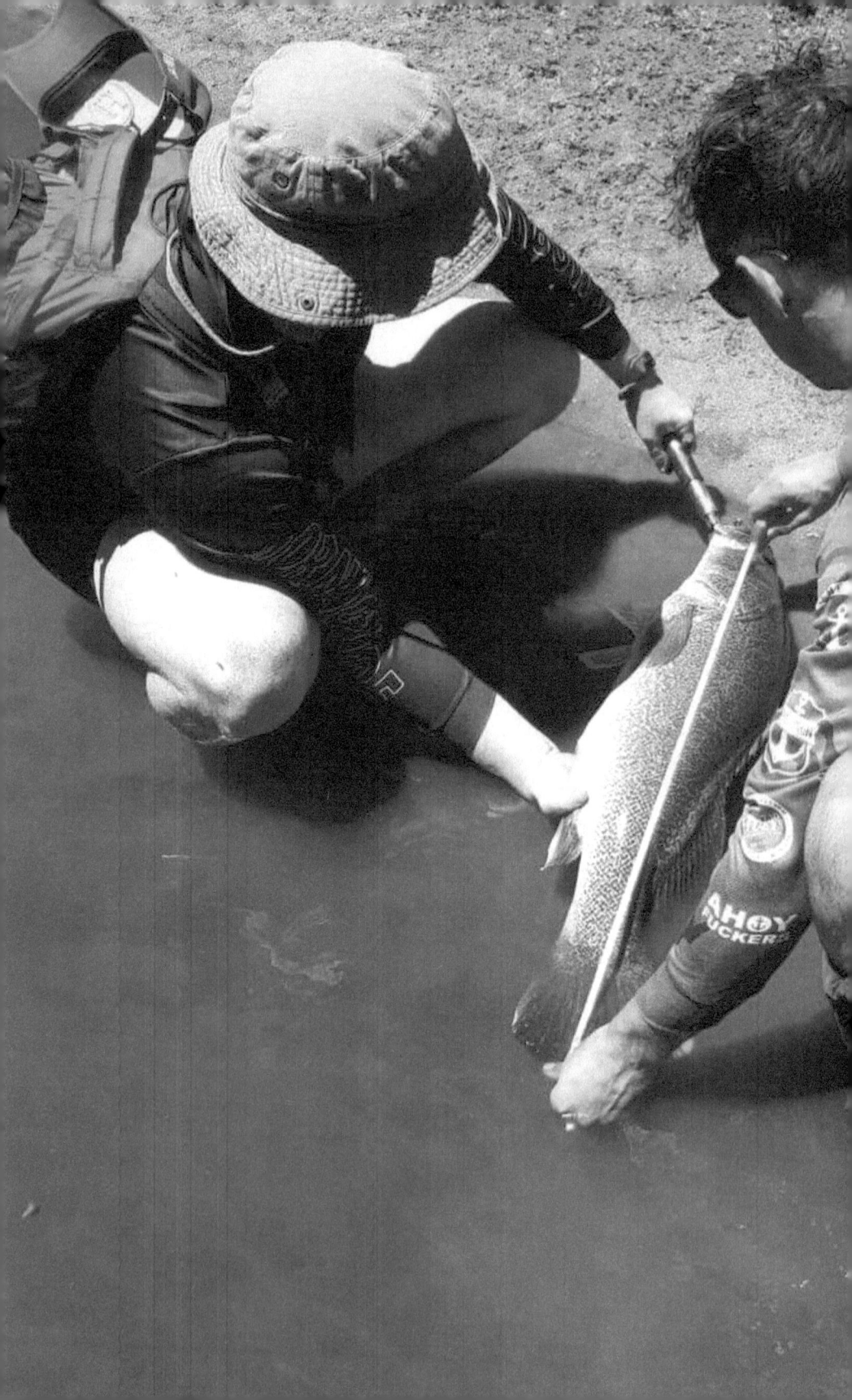

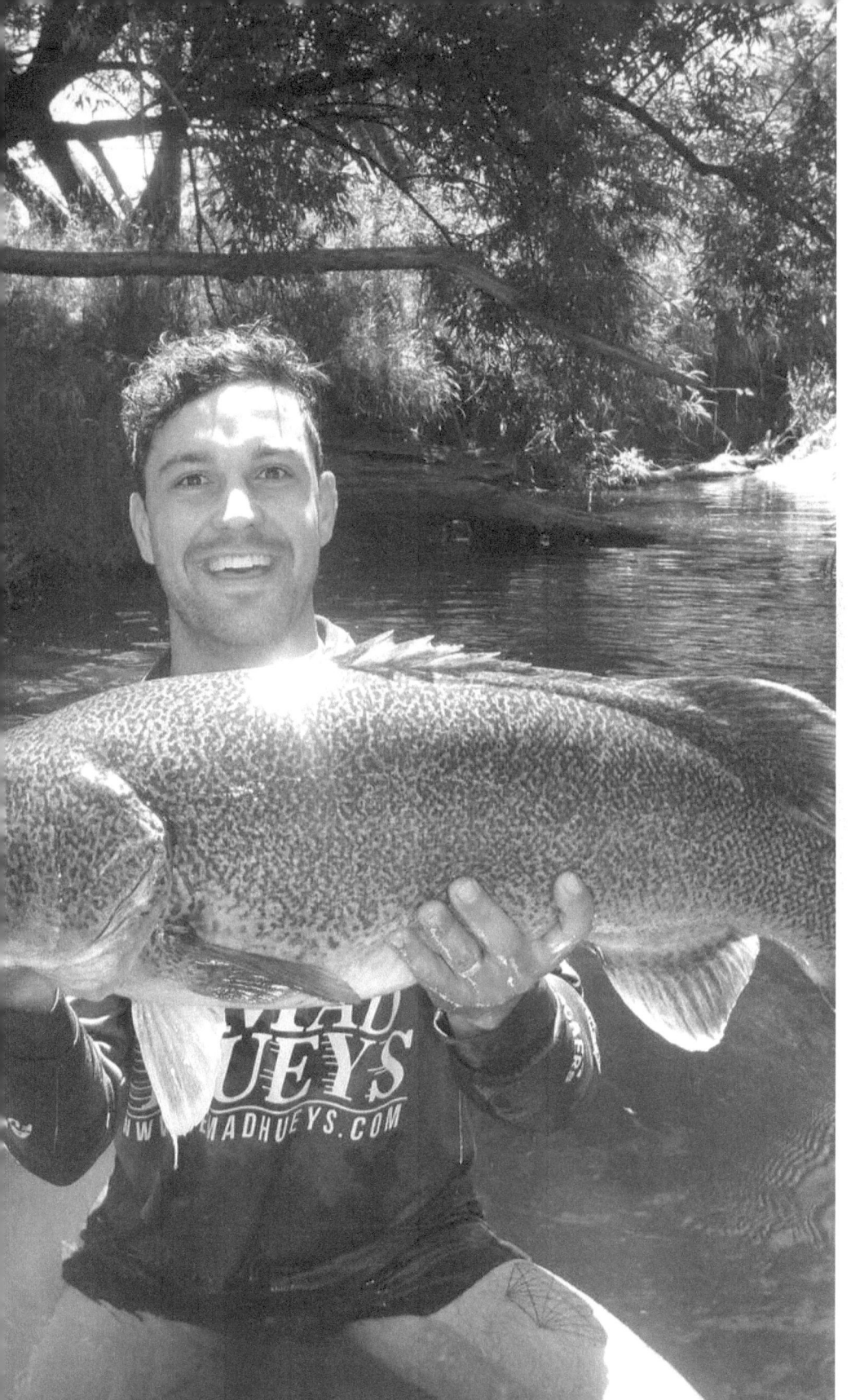

There will be days when the fishing is better than one's most optimistic forecast, others when it is far worse. Either is a gain over just staying home.
Roderick Haig-Brown

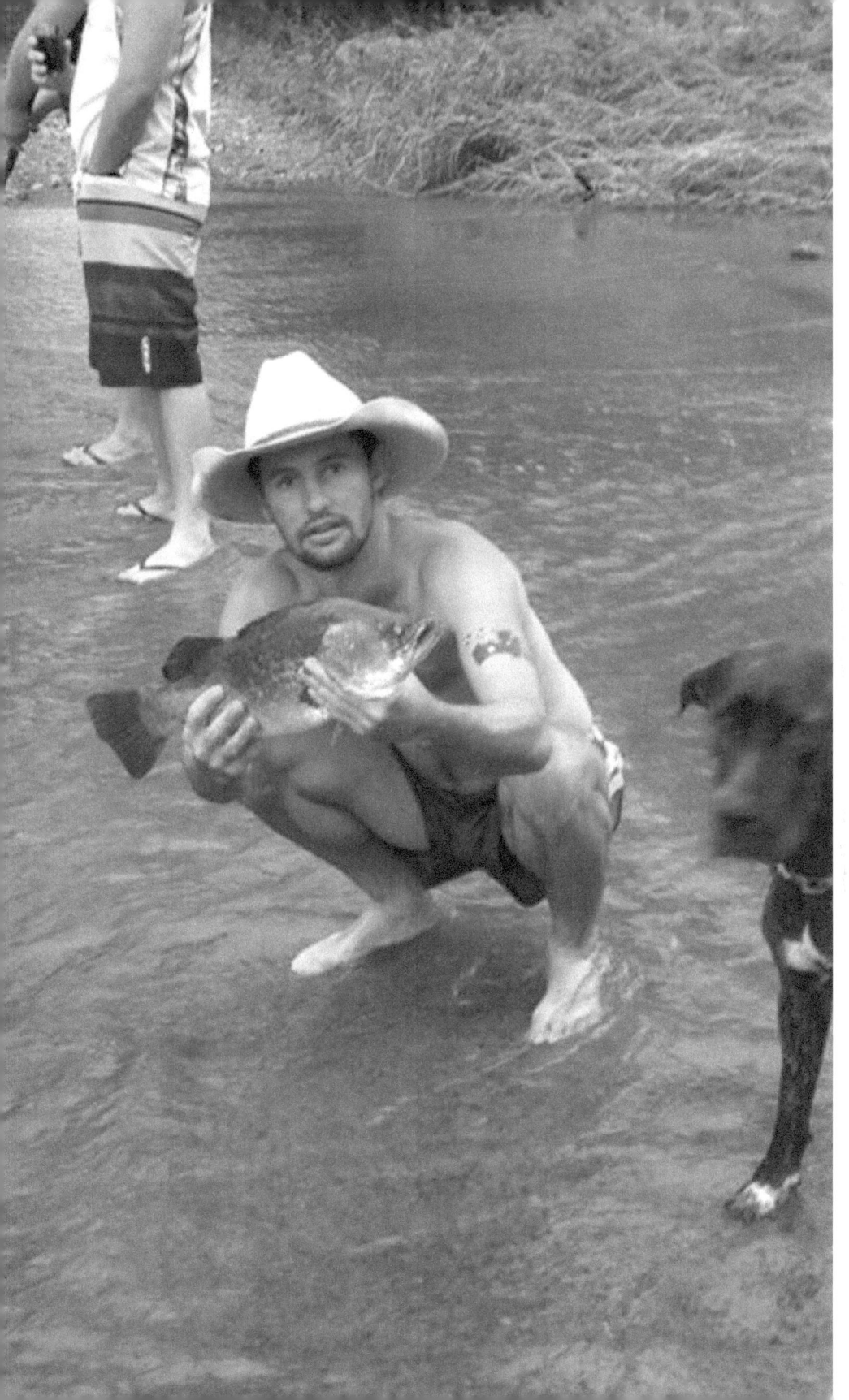

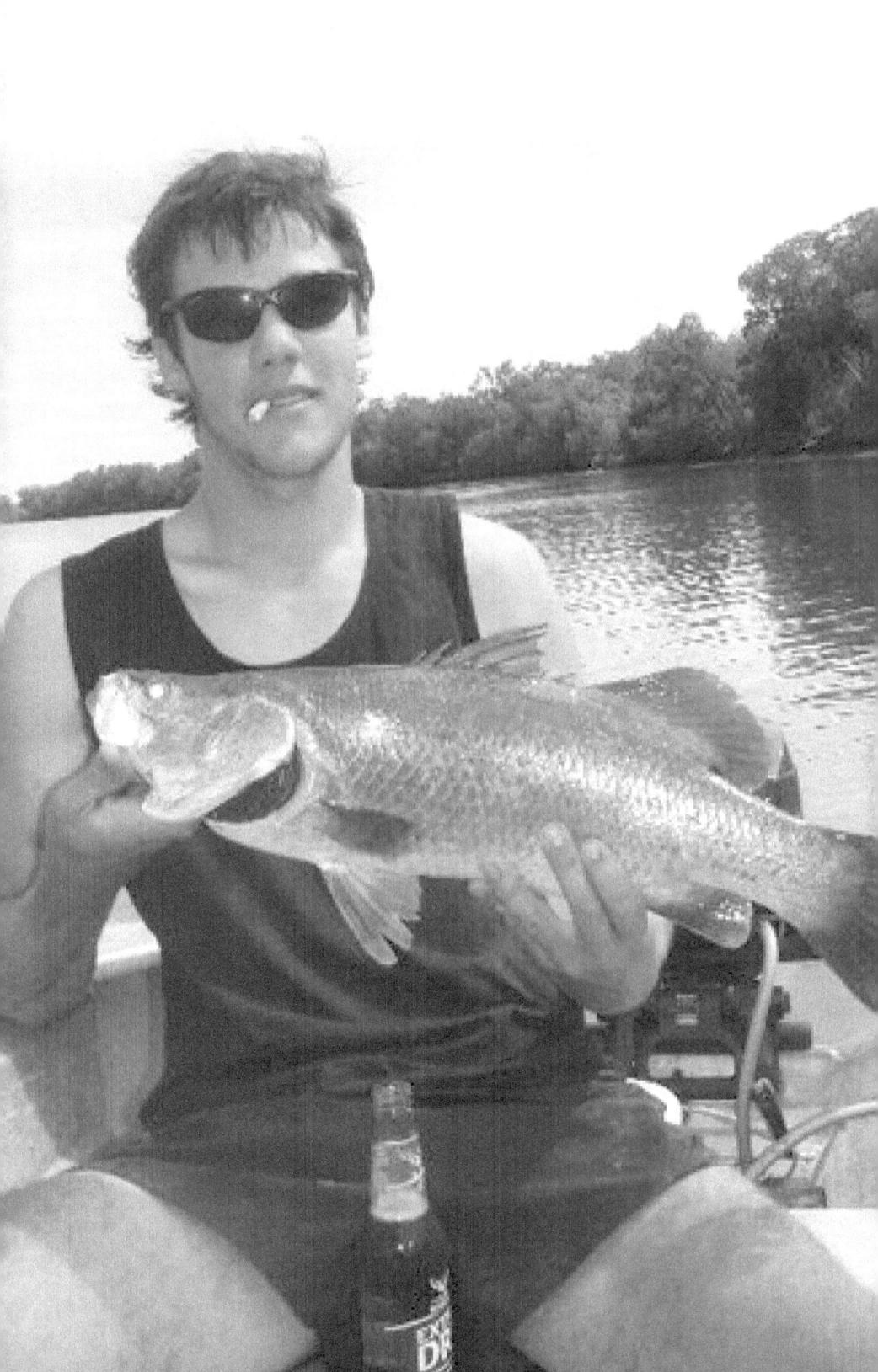

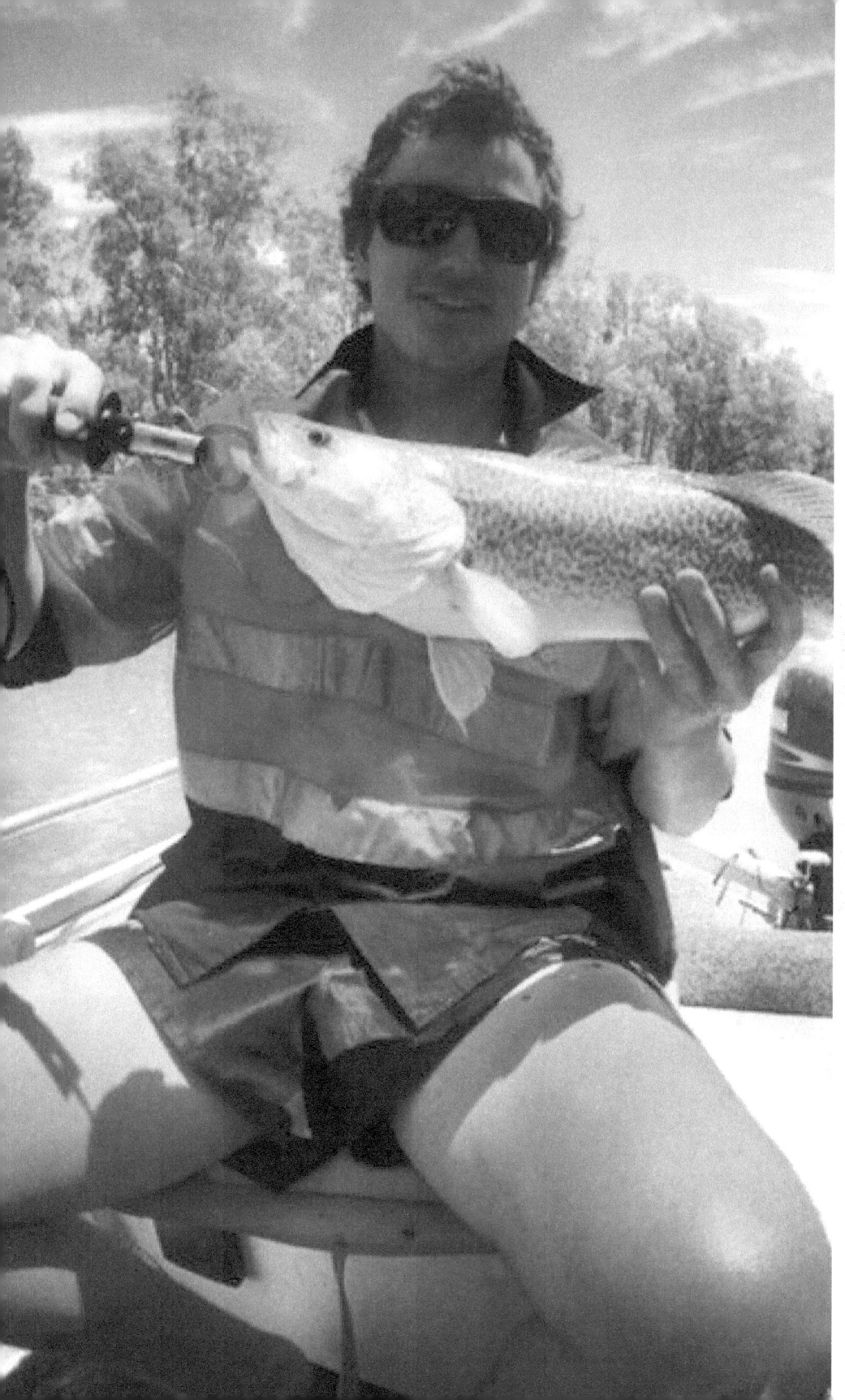

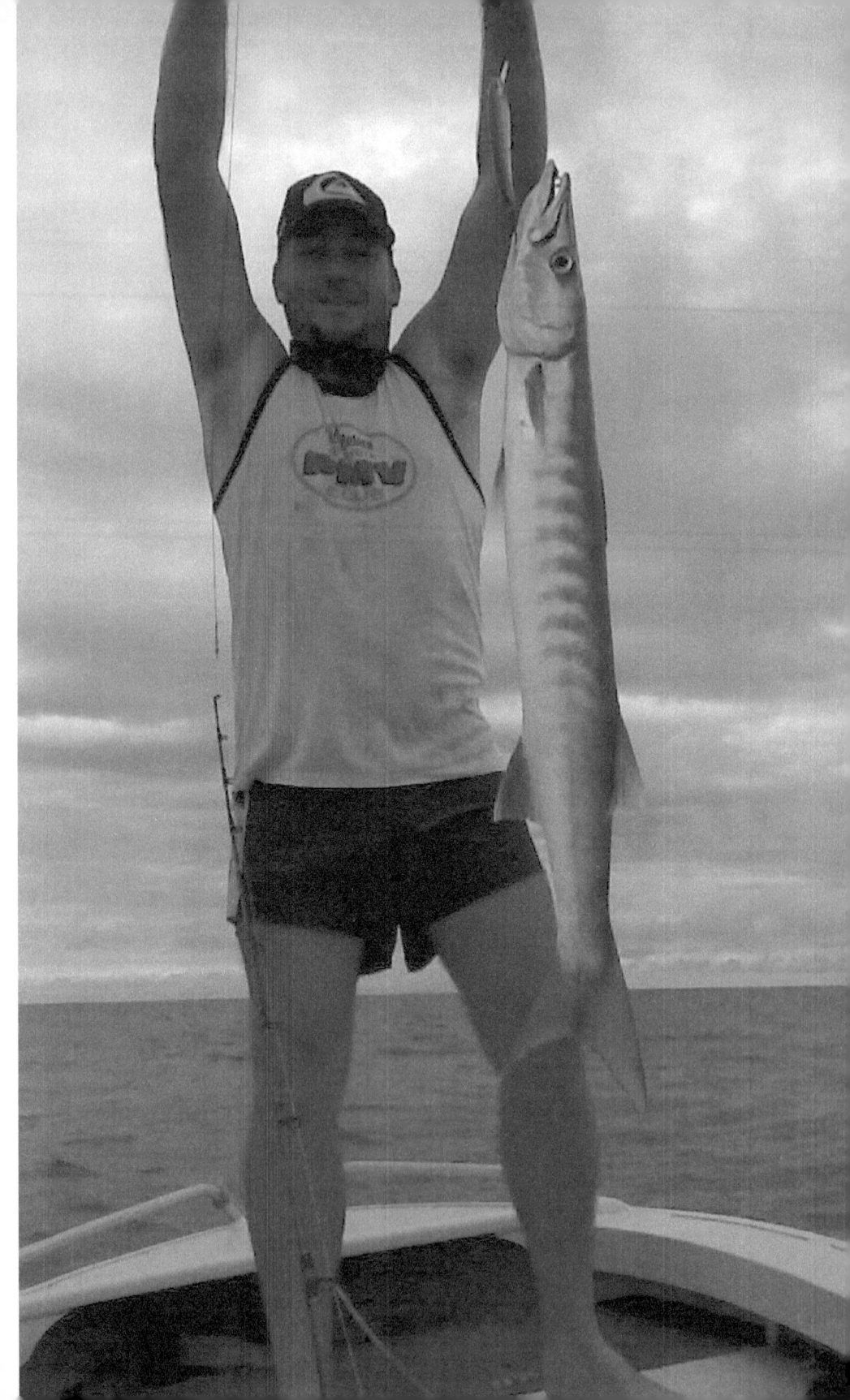

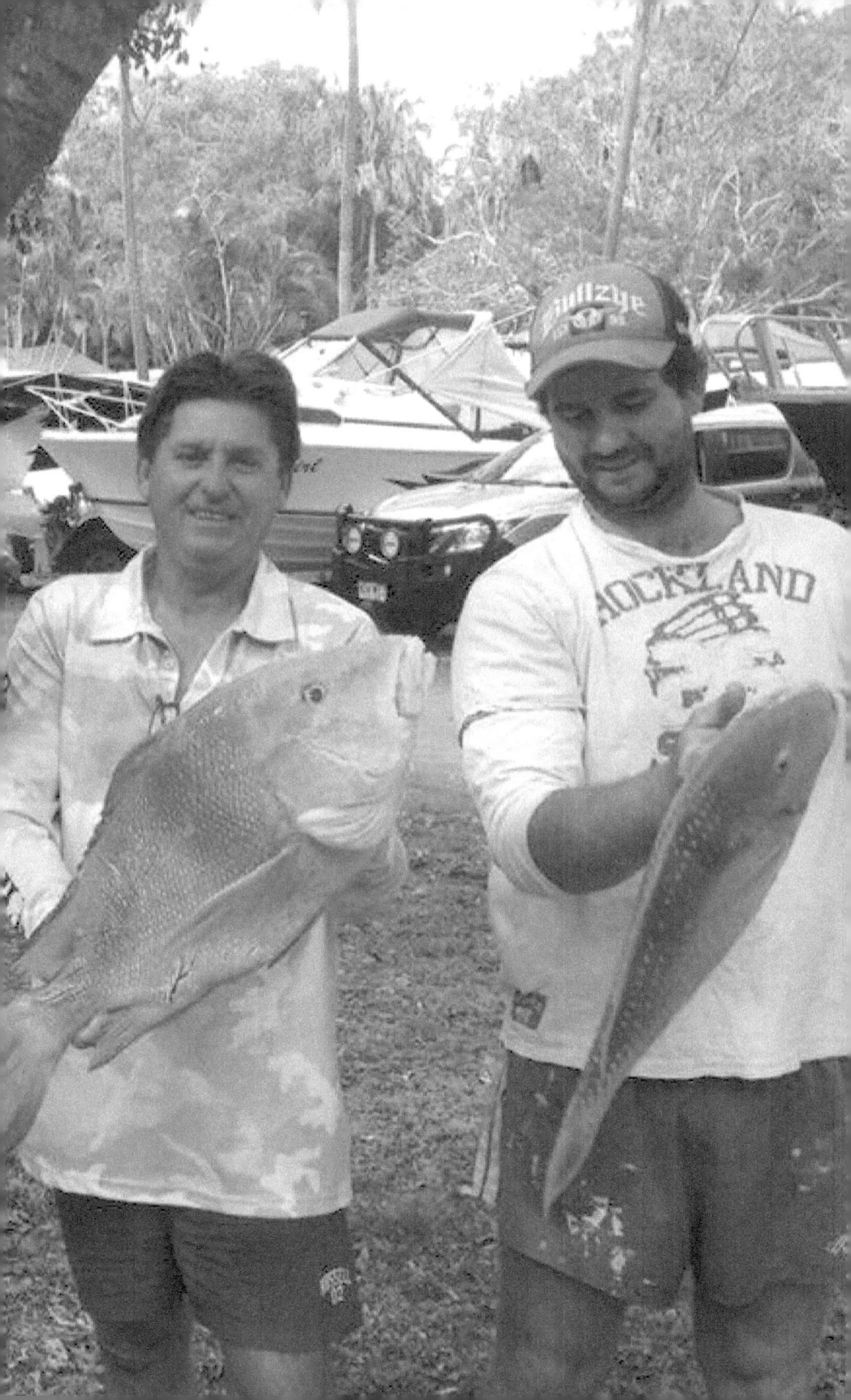

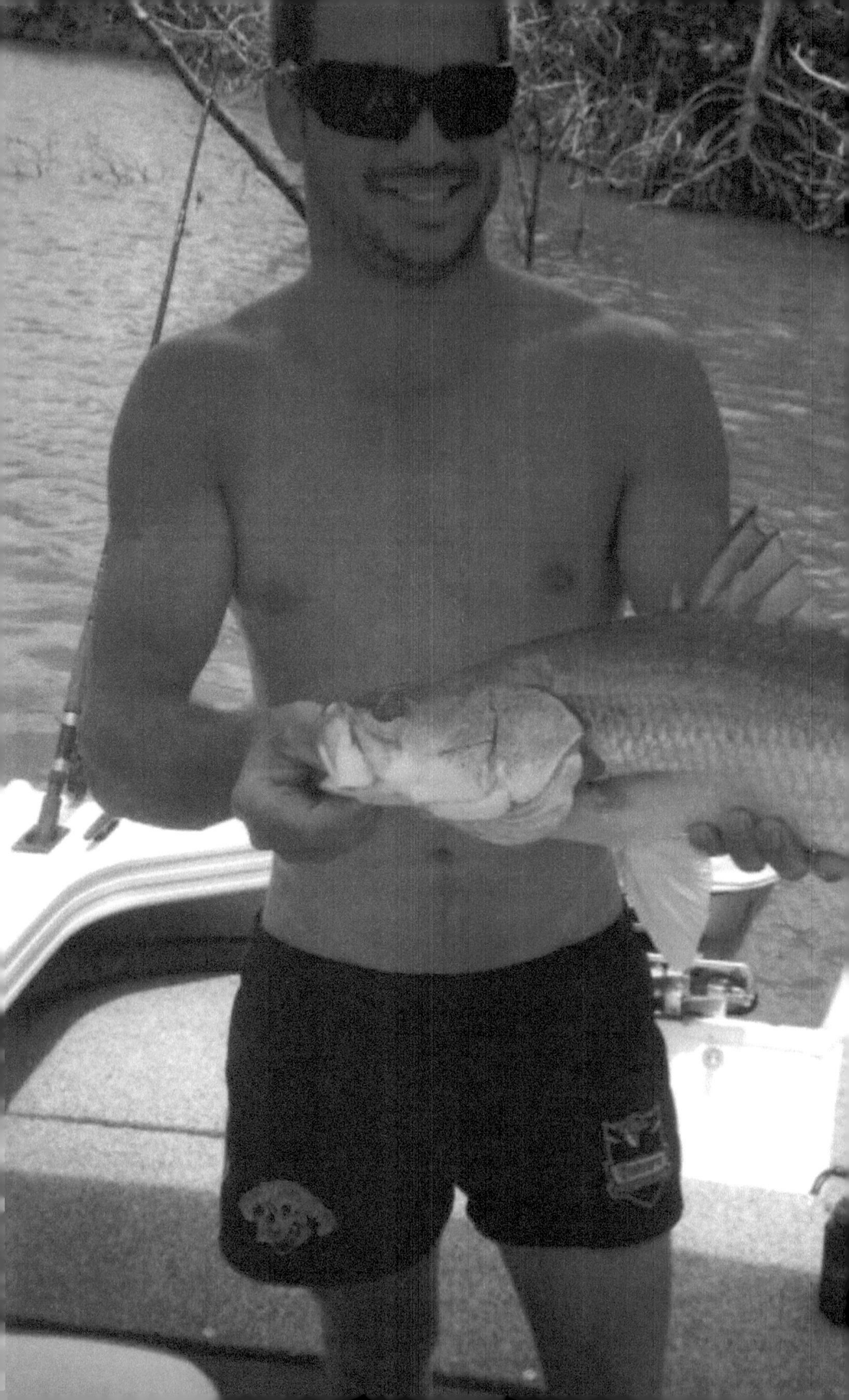

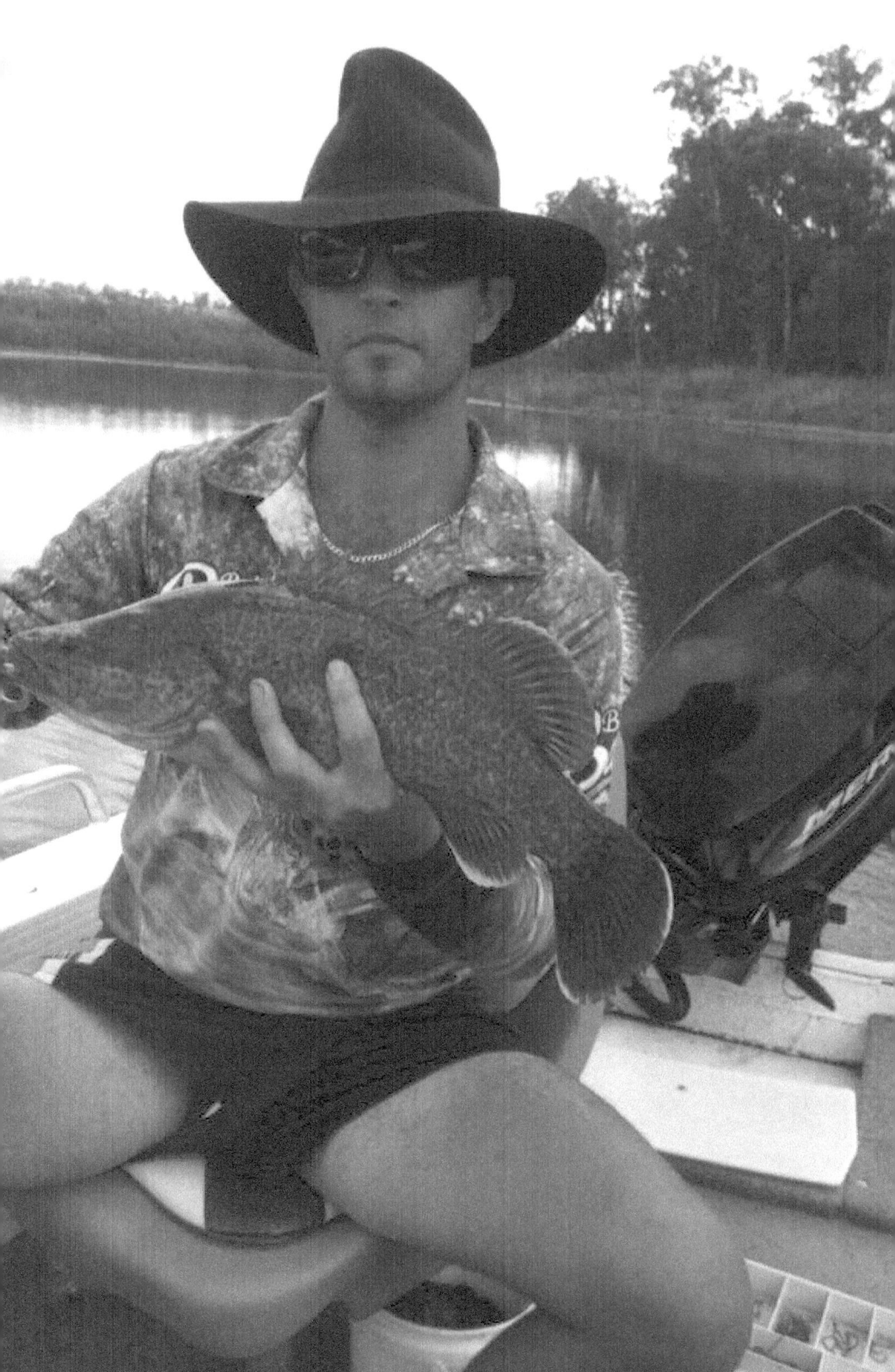

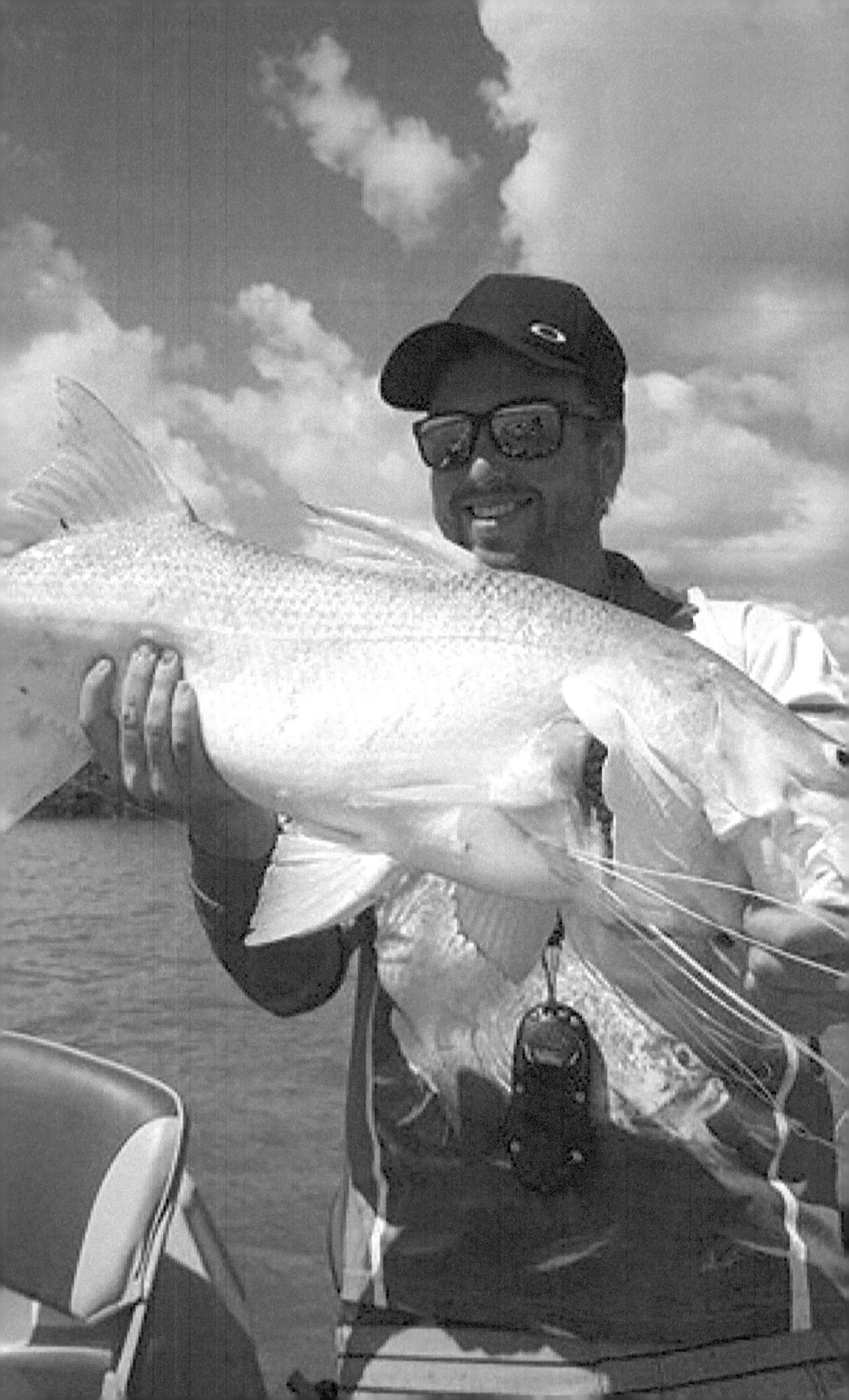

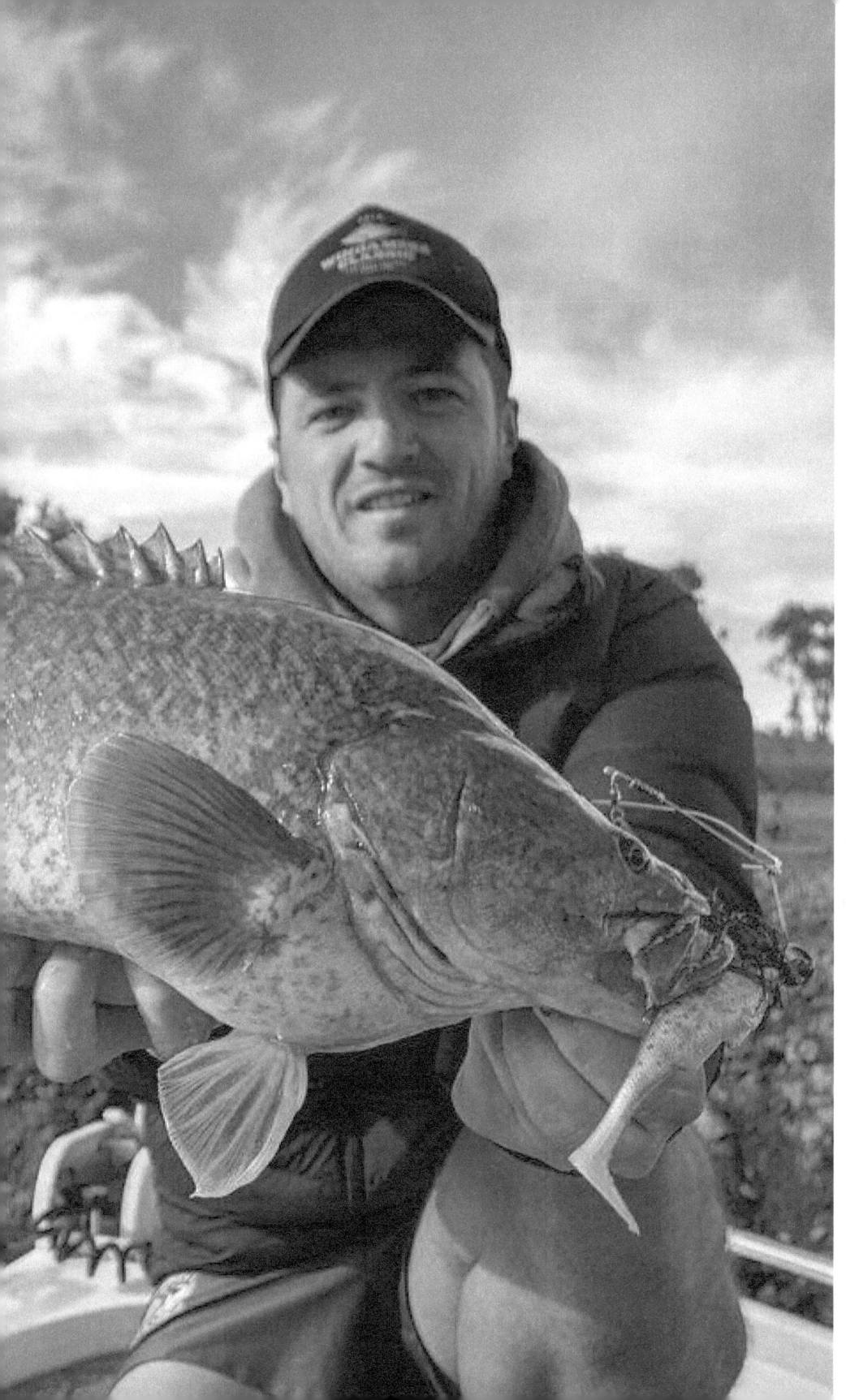

"The solution to any problem —work, love, money, whatever —is to go fishing, and the worse the problem, the longer the trip should be."

— John Gierach

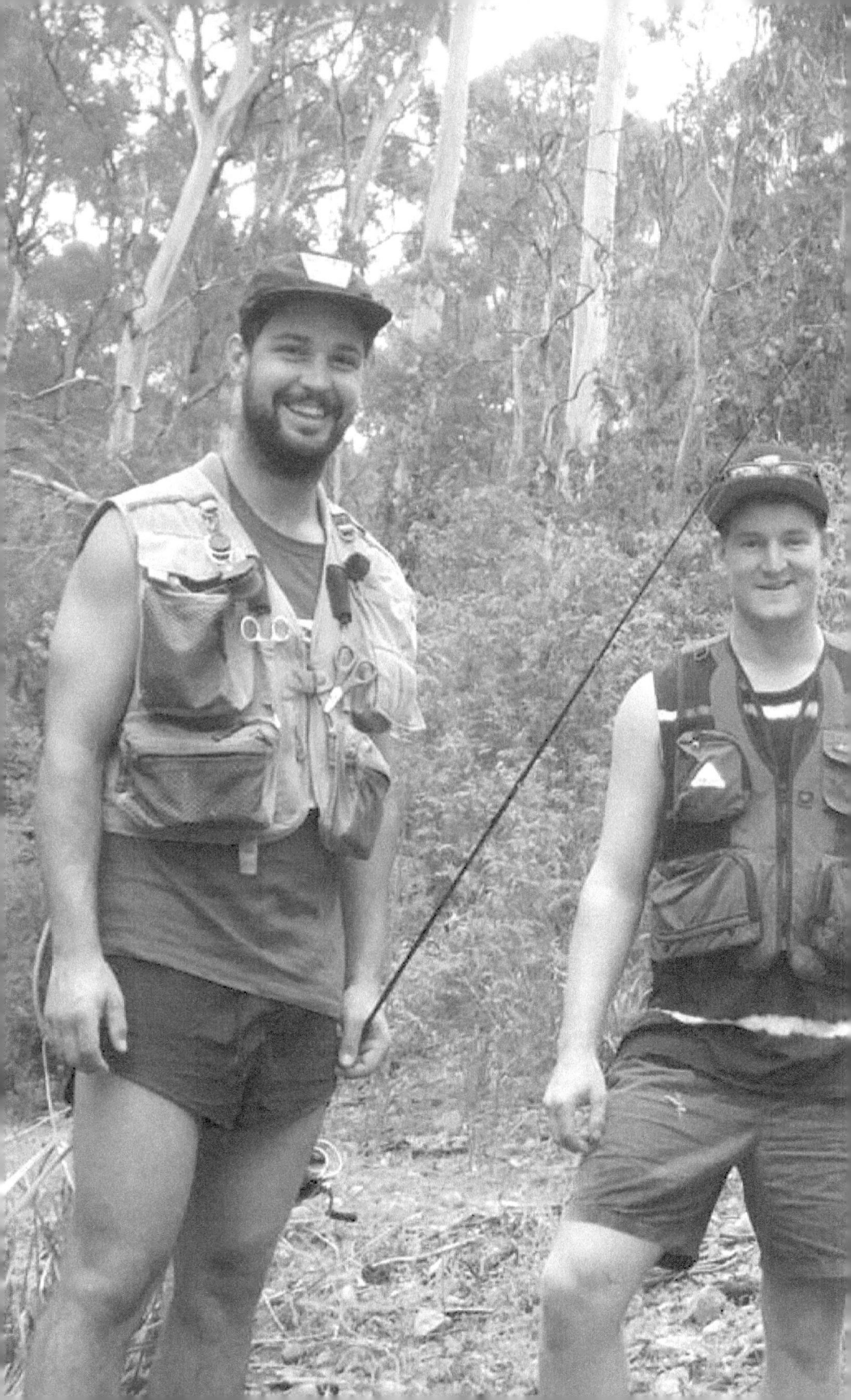

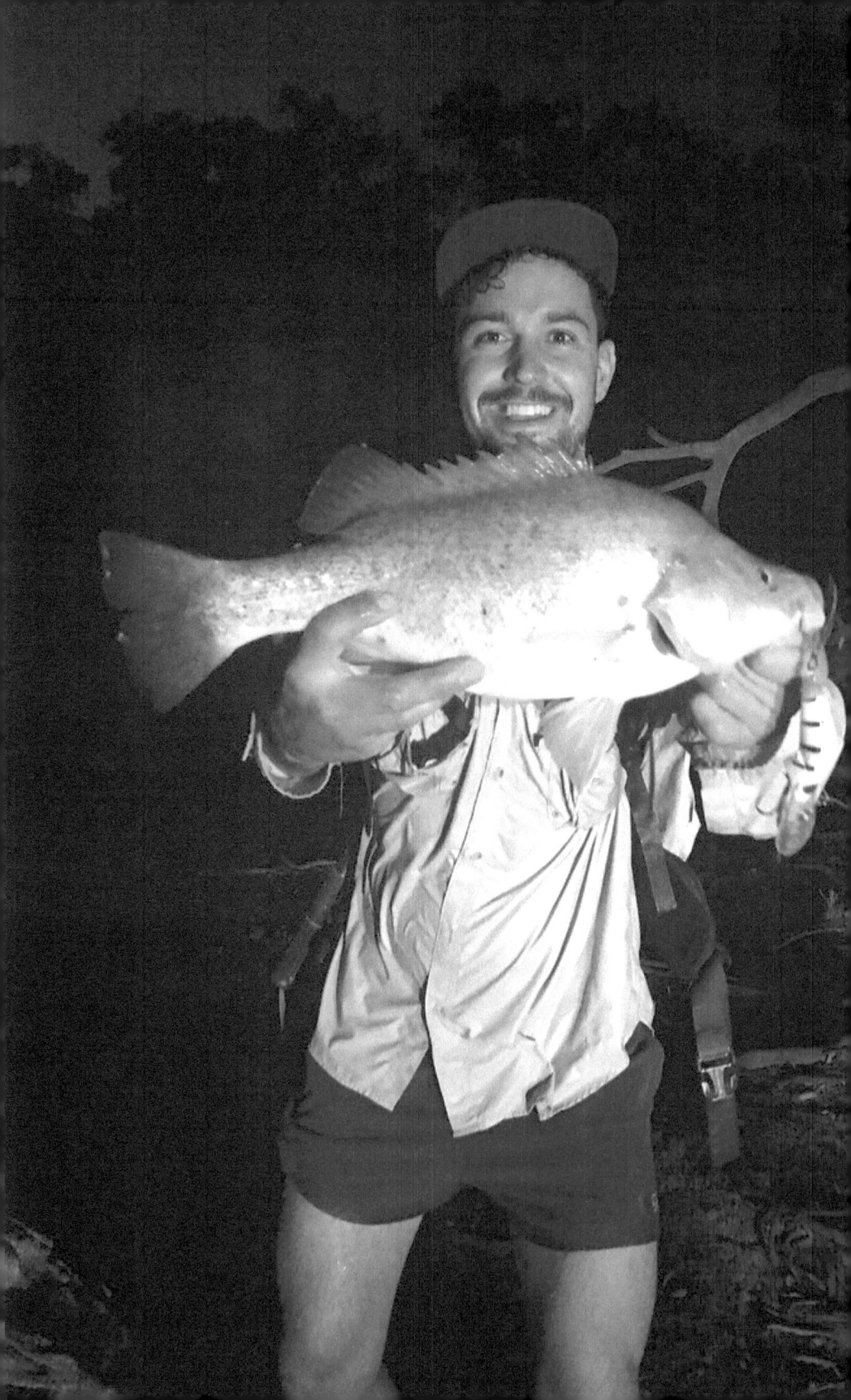

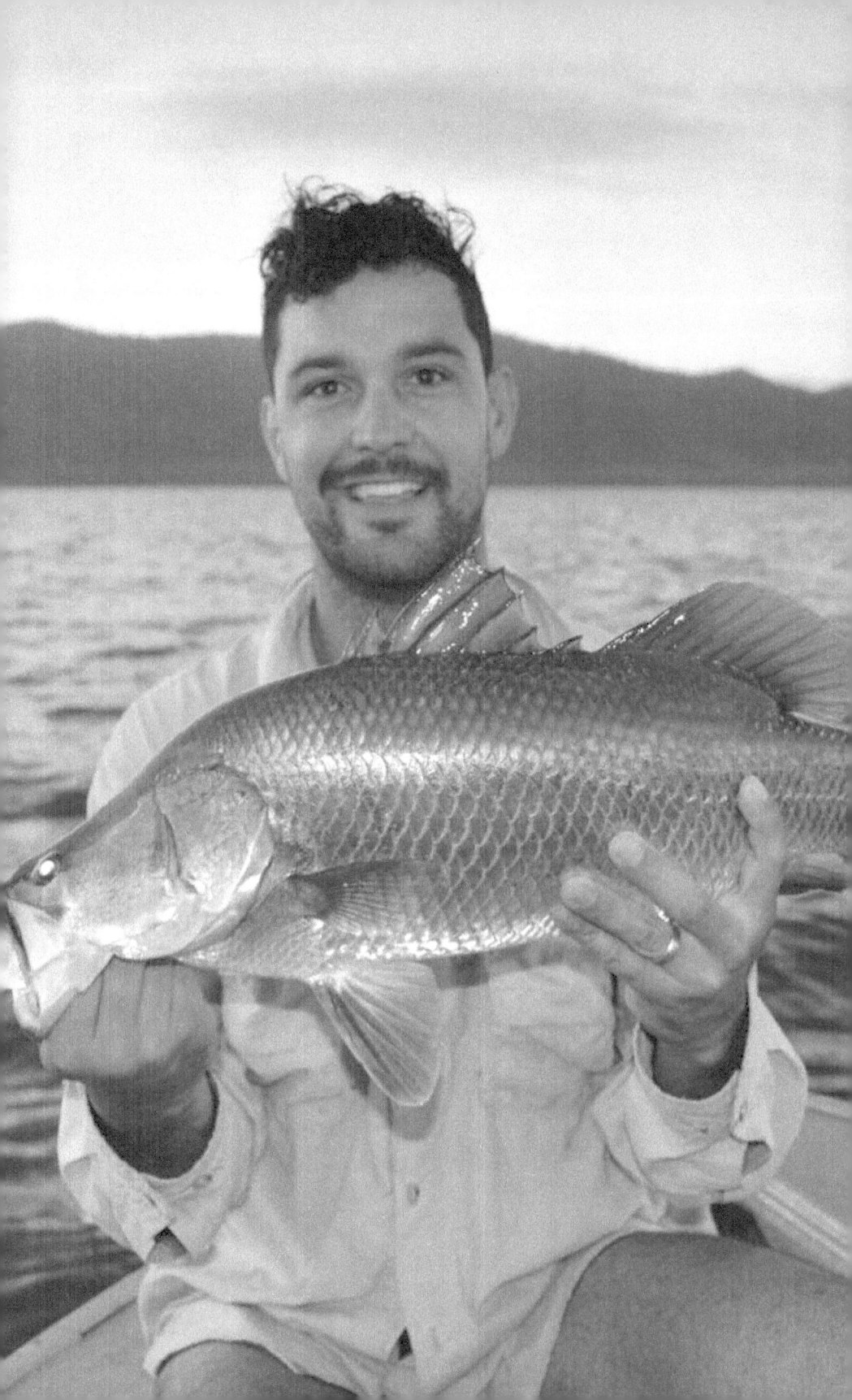

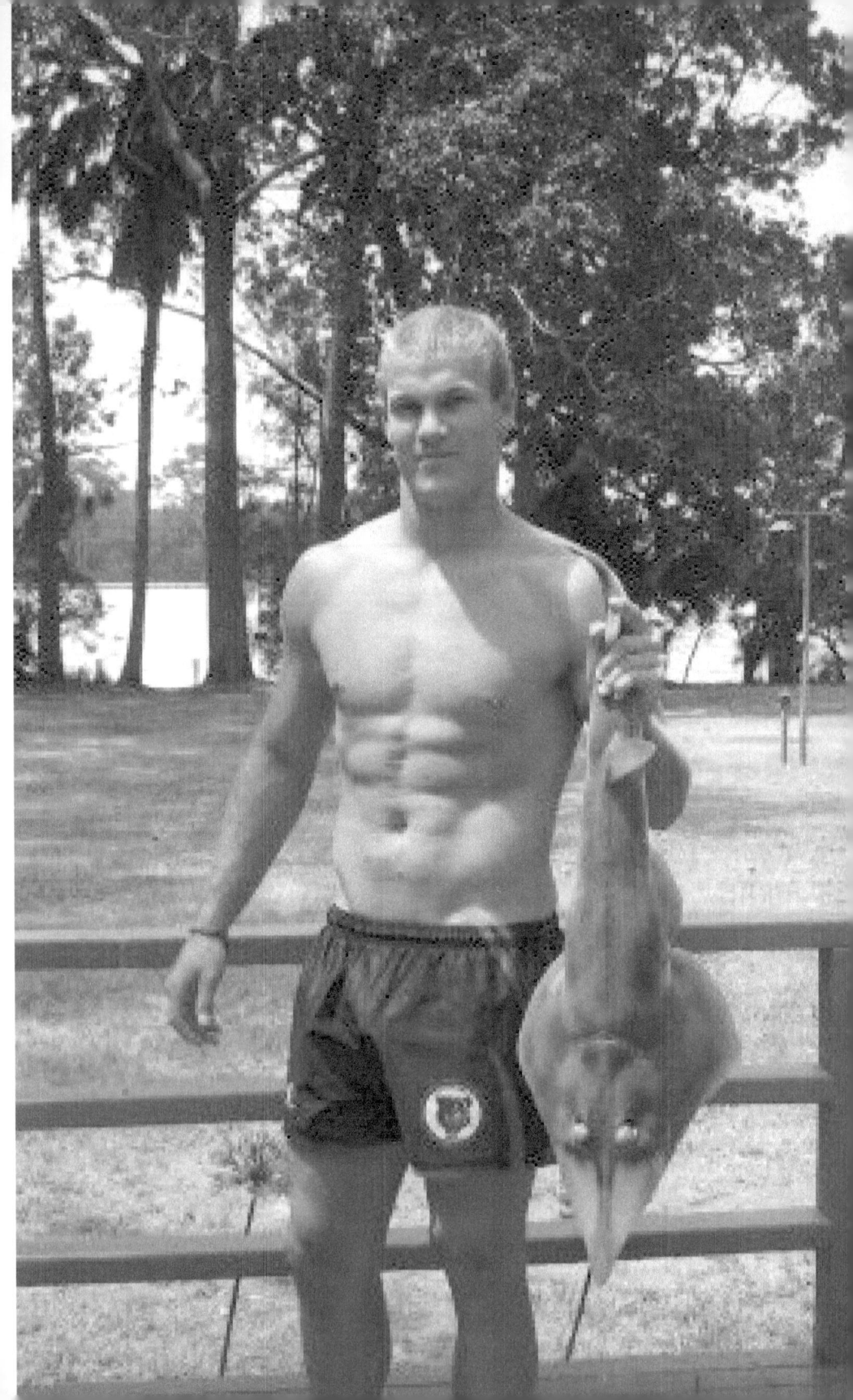

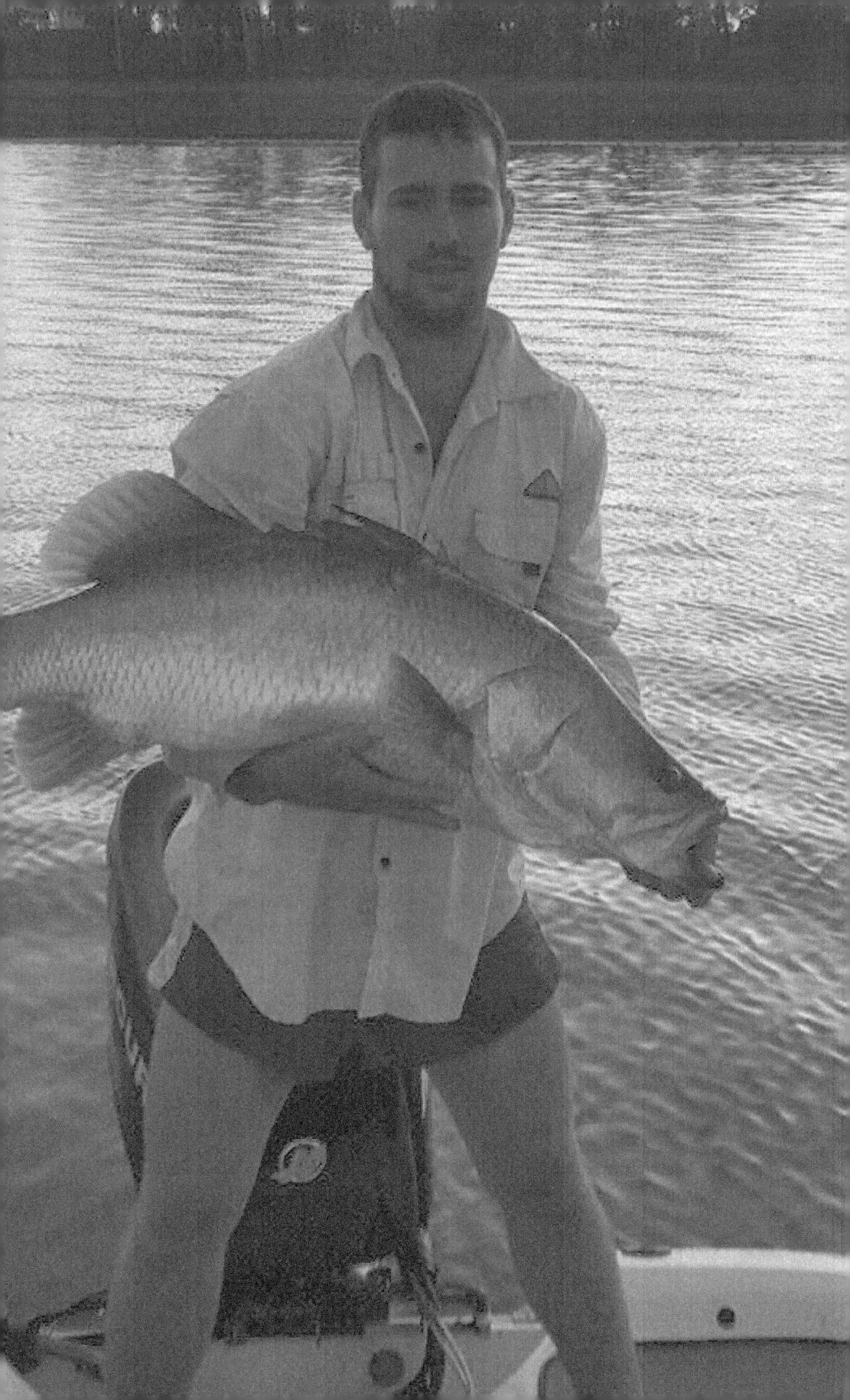

www.ingramcontent.com/pod-product-compliance
Lightning Source LLC
Chambersburg PA
CBHW021309240526
45463CB00018B/884